DIGITAL PHOTOGRAPHY FOR BEGINNERS

COMPLETE GUIDE TO TAKE CONTROL OF YOUR CAMERA AND IMPROVE DIGITAL PHOTOGRAPHY SKILLS BY UNDERSTANDING EXPOSURE, APERTURE, SHUTTER SPEED AND IOS

Table of Contents

Introduction..9

Chapter 2: Choosing Your Area of Specialization in Digital
Photography..15

 Pet Photography..16
 Wedding Photography..16
 Family Portraits...18
 Local Newspapers...19
 Trade Journals...20
 Commercial Photography...21
 Website Photography...22
 Aerial Photography..24

Chapter 3: Popular Subjects Which Can Give You an Opportunity to
Develop Your Photographic Skills..26

 Bugs and Flying Insects..26

 Urban and Suburban...26

 Farm Animals..27

 Zoo Animals..27

 Amusement Parks..27

 Auto and Motorcycle Races...27

 Antique Auto and Aircraft Rallies...................................28

 Ethnic Festivals..28

 Sports Events..28

 Reflections..28

 Sunrise and Sunset..29

Public Art..29

Public Buildings..30

Scenic Landscapes...30

Architecture..30

Creek Beds...30

Clouds..31

Seasonal Changes..31

Cityscapes..31

Churches..31

Pets...32

Children...32

Parties...32

Chapter 4: Various Types of Digital Photography Cameras..............34

DSLRs (Digital Single-Lens Reflex Cameras)....................................36

Mirrorless Cameras...37

DSLR or Mirrorless Camera?...38

Camera Modes..40

Chapter 5: Digital Photography Gear You Absolutely Need..............41

Memory Cards..41

Items for Landscapes and Seascapes...42
Tripods..42
Remote Shutter Release..43

Items for Wildlife and Sports Photography.....................................43
Monopod..43

Items for Portraits and Pictures of People......................................44

Flash unit with diffuser cap..45

Macro Photography...45

Photo-Editing Software...46

So How Much Is This Going to Cost?..47

Read the Manual...49

Chapter 6: Elements of Exposure in Digital Photography.................51

Understanding Aperture..52

Understanding Shutter Speed..54
Shutter Speed and Motion Capture..55

Understanding ISO...55

Steps to Exposure..57
Choose your ISO..57
Ask yourself this question: Is action or depth my priority?...............58
Change the ISO if you can't get what you need out of the aperture or shutter
speed..59

Chapter 7: How to Set Up Your Camera to Get the Most From It......60

RAW+JPEG...60

The Mode to Use...64

Setting the Focus Point..65

Metering Mode..66

White Balance..67

Picture Styles..68

Chapter 8: The Use of Lens in Digital Photography..........................69

Fixed Lenses Vs Zoom...70

Prime Lenses versus Zoom Lenses...71

Crop Factor..72

Aperture..73

Lens Controls..73

Image Stabilization or Vibration Reduction........................73

Manual Focus..74

Using Your Lens..75

Chapter 9: Financial Matters for Digital Photographers.....................77

Speculative vs. Non-Speculative..77

Sole-Proprietor vs. Incorporation..78

LLC Corporations..80

Sales Taxes..80

Chapter 10: Moving Your Photos From Camera to Computer...........83

Getting to Know Lightroom..83

Organizing Your Photos..85

Putting the Photos on Your Hard Drive........................85

Importing the Photos into Lightroom........................85

Collections..86

Ratings..87

Chapter 11: Using Graphic Design Software to Edit Your Photos......88

The Basic Edit..89

White Balance..89

Contrast..90

Colors..91

Removing Spots..92

Cropping..92

Sharpening..94

Noise Reduction..94

Targeted Adjustments..95

Editing Outdoor Photos..96

Fixing the Sky...96

Fixing the Foreground...97

Editing Pictures of People...98
Standard Edits..98
Adjust Brightness Values..99
Sharpen Details...100

Vignette..101

Chapter 12: Displaying Your Photos on the Web............................104

Displaying Your Best Work..105

Places on the Web to Display Your Photos....................................105
Flickr..106
500px..107
Portfolio Site...108
WordPress..108

How to Create Your Portfolio Site..109

Chapter 13: Printing Your Photos...112

Having Prints Made for You..113

Deciding Where to Have Your Print Made....................................113

Preparing Your File for Printing...113

How to Easily Make Your Own Prints..115

Paper Choice..115

Using Lightroom to Make Prints..116
Page Setup...117
Layout Options...117

Print Job...117

Chapter 14: Advertising Your Digital Photography Services............119

 General Advertising...119

 Internet Advertising..121

Chapter 15: Legal Considerations for Digital Photographers............123

 Model Releases...123

 Property Releases..126

 Trademarked Images...126

 Copyrights..128

Chapter 16: How Much Should You Charge?....................................131

 Art Sales..131

 Licensing Fees..133

 Direct Client Sales..134

 Where the Difference is Most Important is in Who Owns the Images
 ..134

Chapter 17: The Power of Flash in Digital Photography...................138

Chapter 18: The Business of Stock Photography..............................142

Chapter 19: Marketing Strategies for the Digital Photographer........146

 Immediate Local Impact...146

 Your Marketing Plan..147
 Market research..147
 Unique marketing points..148
 Exploit potential...149

 Competition..149

 Identify your target audience...150

Articulate your short, medium and long-term objectives..................150

How to choose a stock library...151

Freeing Your Time to Take More Photographs............................151
Hiring a Sales Representative...151
Selecting a Sales Representative......................................152

Chapter 20: Tools and Techniques That can Enhance Your
Photographic Experience...154

ExpoDisk – White Balance and Exposure Settings........................154

ColorChecker Passport by X-rite.......................................155

Spyder4 — Monitor Color Calibration...................................155

Tethered Capture..155

Moveable Eyepiece...156

HoodLoupe...156

Chapter 21: Uses of Histograms in Digital Photography.................158

Chapter 22: Advancing Your Digital Photography........................162

How to Get in Some Practice...162

Ways to Get Feedback on Your Work.....................................164

How to Keep Learning about Photography................................165

Conclusion..166

Introduction

Digital photography isn't mastered overnight. You'll never learn everything there is to know about photography, and that should never be the goal. Enjoy the journey, take plenty of photographs, and learn from your mistakes. Don't be afraid to take some bad shots - only the good ones count.

The technology we have today for all forms of information – including photography – is worlds more advanced than it was fifty years ago. Some things, however, remain the same. When it comes to photography, the best results are still obtained with the standard for photographic art, the single-lens reflex camera.

Whether you are using your phone or the latest and greatest camera available, taking in the moment, and all it has to offer, is really the foundation of a great photograph. Only then, from your heart, can you capture that moment that tells the story as you saw it and experienced it at that time. These are the images that will speak to others and these are the images you will cherish forever. Why? Because they contain emotion behind them. People will always connect to that.

This process will help you take much better pictures in a very short period of time. You will not have to muddle through a bunch of options. Just do it this way and watch your pictures get better.

Why should you bother doing this at all? Because taking great pictures is worthwhile no matter who you are. The process is fun, and the camera acts as a passport to take you to see all sorts of interesting people and places. It also provides you with little mementos of the great times you've had and places you've visited. You'll end up with a tangible thing which might be as simple as something you post to Facebook or a picture in a frame on your desk or a print hanging on a wall in your home or someone else's home.

No matter what you end up with, remember that pictures are the things that everybody says would be the first things they would save in case of a fire. If these are the things that are the most precious items in the world to most of us, we might as well learn how to make them as good as possible.

Chapter 1: History of Photography

The process of making photographs first came to the public's attention in 1839. For several years before that, a few scientists had been able to make pictures, but these were experiments kept largely confined to laboratories.

Then in 1839, France publicized a process of producing pictures on metal called the daguerreotype so named because of the inventor of the process – Louis Daguerre. The following year, an Englishman named William Talbot invented the calotype.

The calotype was a process by which pictures were produced on paper with the light parts of the image showing up as dark and the dark parts of the image showing up as light. These were the negatives. The positives were produced on yet another piece of paper pretreated with special chemicals and presto – photographs, as we know them today, were born.

Two decades later, Frederick Archer would invent a process of producing negatives on glass instead of Talbot's process of using paper. This allowed for the mass production of prints. These prints were also of much higher quality and greater in visible detail.

One early characteristic of photography, which separated it from other forms of art, prevailed from the earliest days of the

invention and continues to this day. Unlike other artists, photographers need to know very little about the means through which they produce their art.

Painters know how colors are produced. They know to mix one color with another to produce a third color. The canvas on which they paint is no mystery. For sculptors, too, the process of producing a piece is simple in nature. The clay is molded then dried.

However, few photographers can explain the mechanics that allow an image to appear on paper by simply pushing a button. Moreover, they don't have to know. Even the earliest cameras, which were clumsy and enormous in size, required little technical knowledge on the part of the photographer.

The ability to produce art through a means that required little time and even less technical skill appealed to the public masses. Particular among them, in the early days of the camera, were trained artists who were not talented enough to make it as painters. In fact, it was from this group of failed painters that photography produced some of the best and most successful photos in the early days of this craft.

Because photography was so new, the earlier practitioners of the art experimented quite a bit. From their experiments came a

wealth of images that are, to this day, considered some of the best in the field of photography.

Much of their work was done for their respective governments, photographing historic monuments and places of particular importance for their countries. Work was also found taking portraits of the wealthy and famous who were already quite used to sitting for painters. But for the most part, these early photographers snapped anything and everything, simply for the experimentation and the adventure, heedless of the need to sell or create art. Photography as a full-fledged business dominated by professionals did not begin until the late 1800s.

Your camera is a complicated machine although in fact a digital camera reduces the complexity somewhat compared to a film camera. The camera body, the lens, the light sensor, the shutter, the light meter, and – what we'll be focusing on in this book – the exposure controls, all contribute to the quality of the images.

The elements of creative photography come down to four things: framing or picture composition, focus, exposure, and graphic image control. The first three of these go into taking the picture while the last is done with the image file afterwards using graphic software.

Of the three picture-taking elements, composition, focus, and exposure, exposure is the most versatile and also the trickiest to master. While all of them are important and deserve a lot of attention, the range of effects that can be created by varying the factors impacting exposure are especially broad and allow much room for creativity. There are several elements to this.

First, you can deliberately underexpose or overexpose a picture for effects. The light meter tells you what exposure to use to produce the best quality picture given the amount of light that's available. Underexposing the image gives you a dark, shadowy picture. Overexposing it gives a washed out effect.

Second, you can vary the exposure triangle while leaving the overall exposure at "optimum." This produces a wide variety of effects, from crystal-sharp panoramas to streaked images imparting a sense of motion, from tightly focused close-ups to detail-revealing stop-motion photography.

Chapter 2: Choosing Your Area of Specialization in Digital Photography

The field of photography has always been a booming business potential. Despite the fact that few people know this, enough of them have figured it out and have created a market saturated with photographers who consider themselves professionals. Because of the advent of digital cameras and the Internet, more and more people are attempting to make a go of photography as a professional career either on a full-time or part-time basis. However, the chances for making a decent career out of photography are still good if one goes about it the right way. Magazines and newspapers purchase more than 60 million photographs each year.

Many of these photos are taken and sold by professionals, and are already established photos. Despite this, there is plenty of room for beginners who are passionate about photography and are willing to specialize.

Beginning photographers are well advised to stay away from certain markets which are already saturated by professionals and which are exceedingly difficult for novices to break into. Well known national magazines and big city newspapers deal almost exclusively with professionals they have used in the past.

Many of these magazines and newspapers also have their own staff of photographers. Trying to sell pictures in these markets can be an exercise in futility and has caused many photographers to quickly drop their dreams of going professional. This does not have to be a situation you find yourself in if you take the time to figure out what areas you are passionate about photographing.

Pet Photography_

This is an area of specialization perfect for photographers who are also animal lovers. Pet owners are notorious for spending lavishly on their adored parrots, pooches and kittens, and also like to show them off. Pictures are a perfect way to do this. Advertising your services to pet owners can be as simple as posting cards or flyers on the bulletin boards of pet stores.

Wedding Photography_

Weddings are perhaps the one occasion in people's lives where pictures are always wanted. A beginning photographer has an advantage over established wedding photographers because they can charge less, especially if they have little overhead such as a studio to pay for. Most everyone knows a friend or family member who has an upcoming wedding, and advertising your

services may first be by word of mouth. Bridal journals are another good place to advertise. Check out your local newspaper's announcement section and send a card directly to the engaged couple, advertising your services and specifying the price you will charge to photograph their wedding.

There are some basic pictures that are always taken at a wedding so that gives a beginning photographer a leg up on the whole process. You already know that the bride will take a picture alone and so will the groom. Then there will be bride/groom photos and, from there, it will gradually expand to include more and more of the family and the bridal party. It is important before the day of the wedding to get a list of the important people the couple will want to have additional pictures of. Usually these are parents, grandparents, maid of honor, and best man. You'll need to be around to take pictures of the toasts that are given to the couple, the cutting of the cake, and the throwing of the bouquet. Become familiar with the basic setup of the wedding service, especially if the couple's religious practice differs from your own. For example, the couple will want to have a picture taken when glass is broken at a Jewish wedding ceremony.

It would be to your advantage if you could take as many pictures as possible before the actual ceremony. Brides and members of the bridal party are notorious for being late in their preparations

so, often, the groom and his groomsmen may just be standing around waiting. This is a perfect opportunity to pull them aside for pictures and to take group pictures of the audience. Don't forget that the couple will also celebrate wedding anniversaries so be sure to mention to the newly marrying couple that you are available for taking pictures five years down the road. Older couples in the audience should also be approached since 25th and 50th wedding anniversaries tend to involve big celebrations.

Family Portraits_

Parents love to take pictures of themselves with their children. It is a way to remember them young and chart their growth. Becoming a family portrait photographer requires very little overhead. Often families will want the pictures taken in their own homes. And even if they don't, you can use a room in your own house as a "studio." Simply purchase a decorative poster or sheet to tape to the wall and you can use that as a background. Advertise your services where families frequent such as the local library or the local supermarket. The traditional yearly school pictures are also taken by portrait photographers, so once you have a nice-sized portfolio, contact your local school district and find out the procedure for putting in a bid for the school picture contract. Many towns and cities have several school districts

within their borders so be aggressive and make bids for all the districts that are a comfortable distance from you.

Local Newspapers_

While big city newspapers and national magazines are almost impossible for a novice photographer to make a living from, small town newspapers almost always use freelancers. Their budgets often do not allow them to keep a full time photographer on their staff. And even in cases where they do have one, that one photographer could not possibly cover all the events of one town or county.

Small town papers are more involved in local events and local personalities than they are in national news which is covered by papers better financed for such work. In fact, small newspapers get their national and international news from press conglomerates and wire services. The bulk of their time, therefore, is spent covering events of local interest.

By attending council meetings, high school sports' games, weddings, parades, festivals, religious events, and even parties of local VIPs, a photographer can make a good sideline selling pictures to the town's paper.

In addition, by maintaining a good relationship with the paper's editors, a consistently decent photographer is likely to be called upon as a freelancer for the paper.

Trade Journals_

Trade journals are those that are geared to a specific specialty. There are trade journals dealing with just about everything imaginable from roofing to hair braiding and from herb growing to woodworking.

You probably have a hobby or an interest that is rather specific and, chances are, there is a journal devoted to it. Do a general search using the Internet or your local library's reference section for keywords relating to things that interest you. Once you find a journal on that topic, flip through several issues and see what kind of photographs they publish. You may stumble onto a lucrative business opportunity that few other photographers would think about.

Along the lines of trade journals are special interest magazines. These are more general than trade journals but they, too, are geared toward a specific topic. While trade journals are often available only through subscriptions, specialty magazines can often be found at large, well-stocked magazine stands.

Specialty magazines might deal with hobbies such as rock climbing, knitting, gardening, or weightlifting. There are also specialty magazines for mothers of preschoolers, African-American teenagers, nursing professionals, vegetarians, dairy farmers, etc.

Commercial Photography_

Banks and mortgage companies need to keep updated and accurate records of the properties in which they are invested or own. Because so many companies are merging and becoming national, there is a growing need for subcontractors to assist them in keeping track of properties that may be hundreds or thousands of miles from their headquarters. It isn't cost-effective to keep full time or even part time employees in every locality that the company may own properties. It is much more efficient to hire photographers on a freelance, as-needed basis and that is where you come in.

The obvious properties that come to mind when one thinks of banks and mortgage companies are houses. But boats, apartment buildings, shopping malls, and other structures housing businesses all have mortgages on them. Some mortgage companies that hire freelancers may be near you so start by checking the yellow pages. Once you get in touch with them, let

them know you are available on-call for photographing properties and give them your general geographic parameters; that is, let them know how far you are willing to travel. Just as it would be inefficient for you to drive miles to take just one picture, it would also be inefficient for the mortgage company to hire you to do this. So more likely than not, when you are called for an assignment, they will have a list of places they need you to check out.

When you go see these prospective clients in person, don't forget to bring along a portfolio tailored just to the kind of work they would need done. Take great pictures of houses and other properties and remember to photograph all sides both up close and from a distance. This will approximate the kind of work you would be doing for these clients and will impress them more than candid black-and-whites of your Uncle Sal.

Website Photography_

Just about everyone these days is setting up his or her own website, it seems. The desire to be on the worldwide web just might rival the desire to start one's own photography business. Both those who want to put together their own websites and professional website designers need photographs. Of course, this need is only perceptional. A website can be up and running

just fine by using nothing but text. But websites look better with graphics and pictures and website owners and designers know this. Website owners and designers, though, are not necessarily professional photographers and do not necessarily have their own stock of pretty pictures to paste on their website in order to draw the online masses to visit them.

A professional photographer who is computer savvy can make a business out of licensing their photos specifically for this use. Actually, a professional photographer who is just moderately competent with computers can make a go of this specialization. What you need is lots and lots of photographs and the ability to post them on the website that you will create, or the ability to needle a friend into creating a website for you. Once that is done, you want to use keywords for search engines that will draw website designers and ordinary folk to your site to browse all the great images that could be gracing their website. Presto – a business is born.

The downside? It should be obvious. Because your images are already online, what is to stop those website coveting folks from simply copying the images they want from your website and posting it on their own? The answer is "Not a heck of a lot." This is where the importance of copyrighting comes in. Make sure that all the photos you post are registered with the U.S. Copyright Office before you post them. Place your copyright

symbol and name directly on the photograph by digitally superimposing them so that, if infringers are caught, they can be slapped with extra fines for removing them.

Aerial Photography_

Are you not only a photographer but also a daredevil, a risk taker or simply someone who loves to fly? Aerial photography may be the specialization for you. There are several groups of clients who are in the market for photographs that need to be snapped from up on high. Real estate developers are one. Aerial photographs allow them to better configure the plans for the residential or business communities they wish to build. There are aspects of any natural terrain that will be important for builders to take into consideration but are only clear from an above-the-site view.

Local and state government entities also need aerial photographs. These photographs are used for everything from making maps to determining city and town boundaries. Aerial photographs are also great for artistic projects that you may later sell for use on postcards, calendars, or posters. The trick is to take advantage of your time in the air because hiring a pilot will be an expense significantly greater than expenses incurred in other photography specialties. While some of this expense can

be passed onto the client, you can take advantage of already being up in the air by snapping as many pictures as possible so that you do not need to re-hire a pilot when it comes time to build your own portfolio.

Chapter 3: Popular Subjects Which Can Give You an Opportunity to Develop Your Photographic Skills

There are a number of popular subjects that will give you plenty of opportunity to develop your skills. Let's start with nature.

Bugs and Flying Insects

This category is even more challenging than flowers in that your subject isn't likely to stay in one place for very long. You may find yourself running all over the place to get a good shot. You are also more likely to hand-hold the camera than use a tripod even though tripods often work very well.

Urban and Suburban

Wildlife such as rabbits, squirrels, and birds can be a lot of fun to photograph and will teach you a few things before you set out for the wilderness.

Farm Animals

Horses are particularly difficult to capture in motion and may provide some great learning experiences. Cows, bulls, pigs, and donkeys are also great subjects.

Zoo Animals

A visit to your local zoo might be a whole different experience with camera in hand. The possibilities are endless.

Amusement Parks

You can practice with fast moving subjects like people on a roller coaster or other rides. After dark, the lights on some of the attractions will offer additional opportunities. Try a long exposure that shows the lights as colored streaks and then see if you can stop-action and get a portrait lit by the lights of the ride.

Auto and Motorcycle Races

It is a great way to learn about stop-action photography and using blurred lines to emphasize movement and speed. You can practice panning as well as head-on shots with a telephoto lens. If you are in the right spot, you might even get some great images from a camera on the ground and remotely activated.

Antique Auto and Aircraft Rallies

These are usually very colorful and provide opportunities to learn more about natural lighting. It is also a great place to experiment with unusual angles and close-ups. It will help you to see that less is sometimes more with regard to what to include or exclude from your image.

Ethnic Festivals

Both colorful and animated, these festivals are a great place to shoot in continuous mode, capturing several frames a second. You will soon learn how fast your camera can process those images and how to position yourself for capturing great images.

Sports Events

Whether a professional sports team in a stadium or backyard touch football, there are plenty of great shots to be harvested.

Reflections

Any reflective surface offers an opportunity for an unusual shot and memorable image. Pay attention to water, glass, polished metal, and smooth, stone surfaces. Imagine straight lines projecting from your lens skimming off the surface. If you can

set your camera low with a very shallow angle to the surface, you will get a more expansive reflection.

Sunrise and Sunset

It is the best lighting of the day and a way to make even the mundane look great. A little bit of mist will only make the image more memorable. You will also learn to recognize and appreciate great light.

Public Art

Your lighting will be largely determined by the sun and surrounding objects. You will also have to work around other people going about their daily lives. You can't just rope off the area while you do your shoot. All of these things force you to be creative in how you approach your subject. Most importantly, you are challenged with trying to present another person's art in a unique way that shows something that might be missed by others. We all walk past these works of art with little or no thought to the details and craftsmanship. A great photo can cause us to reflect in a way that we never imagined.

Public Buildings

Public buildings almost always have something of interest to capture. It can be how they blend and contrast with their surroundings or simply their shape and details. Reflections in their windows or the details of pillars are often compelling.

Scenic Landscapes

Barns and old buildings of all types make great subject matter. A tractor in a field or an old farm truck in front of a farm house conjure up artistic masterpieces. A house in the middle of nowhere with scenic mountains in the background is always inviting.

Architecture

Some of the most interesting courtyards are very small and it is difficult to get back far enough to capture the details.

Creek Beds

Even dry creek beds can have their allure. The rocks are often colorful and vary in size and shape. The banks often have interesting foliage that cast interesting shadows. Occasionally

you will discover an old tree growing out of the side of the bank with exposed roots.

Clouds

You want to maximize your exposure without creating "White-Out" areas. When you edit images like this you will be amazed at the details in the clouds.

Seasonal Changes

This is always a great subject. Snow in the mountains and the changing of leaves as well as new growth in spring.

Cityscapes

During the day, traffic patterns in the street and on sidewalks can be captivating. At night the city lights are often beautiful even in rundown areas of town.

Churches

Houses of worship often have some very interesting architectural details. Stained glass windows, arches, and steeples are just a few noteworthy details. In older and larger

churches and cathedrals there are usually statues and columns on the interior as well as exterior.

Pets

Pets are always a great source of subject matter. Try to get down to their level as often as possible. They also don't always stay where you want them.

Children

Probably the most popular category of photography. If you want to get the best snapshots, try to get down to their level and catch them in natural activities where their personalities shine through.

Parties

Wedding photography is the easiest road to becoming a professional photographer, not because it is easy but because of the demand. Besides the planned shots for the album, you will also be taking a lot of candid shots at the reception. There is a skill to getting great shots without people even noticing your presence. Learn to shoot indoors without a flash and you are well on your way to stealth photography. Parties provide a great training ground for those candid images. You will probably

attend more parties than weddings so you will have plenty of opportunity to practice your art.

Chapter 4: Various Types of Digital Photography Cameras

With the advancement of digital photography, the world has been opened up to many various types of cameras. It can be quite confusing and intimidating to stand in a store and see all of the cameras lined up. Many of them look identical, yet the price difference can be hundreds, if not thousands, of dollars between various models. So, what is the difference? Why do two cameras that look identical sometimes vary in such extreme costs? This is why it is important to understand camera design and what the manufacturers are trying to sell to you, the consumer.

First, you must understand that to gain creative control, you need a camera that allows you to adjust the manual settings.

There is no difference in the types of pictures digital and film cameras take. Both cameras are adequate for taking pictures at night or in bright sunlight, of action or portraits, of long distances and close-ups. The results depend on the knowledge of the person holding the camera, not in the camera itself. But

there are reasons why one might choose digital over film or vice versa.

Digital cameras are best for those for whom picture taking is extremely casual, like snapping shots of family outings or of the kids' baseball game. Digital cameras are also a good option for those who plan on taking a lot of pictures. Though digital cameras are more expensive than traditional cameras, if you take enough pictures, the money saved on film and processing will eventually offset the original expense of the digital camera. Digital cameras are also best if you plan on posting lots of pictures on the Internet or if you simply like to have your results immediately but want better than Polaroid quality pictures. And if your picture taking purposes do not require super large prints, the digital camera may be the way to go.

On the other hand, many magazine editors still require that the film negatives be submitted along with prints. If you work for several clients in this category, it may not benefit you to spend the money a good digital camera requires. Film cameras also, of course, allow you to develop your own film which many people consider a hobby in and of its self. And film cameras are the way to go if you should need prints larger than 14x20.

This means that you can control the three elements of exposure you will be learning about in the "Elements of Exposure"

chapter. These elements are the ISO, the shutter, and the aperture. If your camera does not feature those manual settings, you will be unable to make the needed adjustments to harness the light for what you want, rather than what the camera wants. You will find that this is the key to being able to control the aspects of your photography outside of composition. Here are the commonly used types:

DSLRs (Digital Single-Lens Reflex Cameras)

Most DSLRs contain full manual settings. You also get the ability to change lenses with a DSLR. This is much better than built-in lenses as the quality and your creative ability to control and manipulate your images according to preference is far greater. A DSLR camera also has no delay when pressing the shutter button. In other words, when you press the button, the image is taken instantaneously. No more missing the shot as you wait for the camera to take the picture!

DSLR cameras are typically more expensive, but offer a much greater ability to control the results of your final images. There are several brands that manufacture exceptional cameras in various price ranges. Canon, Nikon, Sony, Olympus, Pentax and others all offer great DSLR cameras. Canon and Nikon tend to be the most popular and are highly respected brands.

The traditional workhorses of quality photography are **DSLRs** or Digital Single-Lens Reflex cameras, and you will not go wrong with one of these. The first question will be which brand to get, and here you should stick with either Canon or Nikon which have been the gold standard of DSLRs for many years. It doesn't matter which one you choose as it is like deciding between Home Depot and Lowes – they are basically the same thing but set up a little differently.

Within the Canon or Nikon brands, get the cheapest, entry-level DSLRs available with the kit lenses. In the Canon world that is presently the Canon T6i (or 750D outside the US), and in the Nikon world it is the Nikon D5500.

Mirrorless Cameras

This is the fastest growing segment of digital photography at this time. This is due to the fact that you can get an amazing quality system, with less weight than a DSLR in many cases. All the manufacturers are producing these nowadays; however, Sony, Panasonic, and Olympus are in the forefront with Sony far ahead of the game as the leader in mirrorless technology and quality.

First things first: You need to be set up with a camera and lens to do the photography. There is no sense talking about anything

else until you have that squared away. Plus, cameras and lenses are what everybody wants to talk about.

If the size of the camera is a big issue for you and you want the smallest camera possible, either because you are getting on in years, you want to carry the camera in your purse or large pocket, or are hiking many miles a day, get a mirrorless camera. They are very small and the quality has improved markedly in recent years so that they are very close, if not equal, to that of DSLRs. Because of their small size, they are also a little cheaper.

If you decide to buy a mirrorless camera, look no further than Sony. Specifically, get the Sony A6000 and the 16–50 mm kit lens. When this camera was introduced, it sold for $800 with the kit lens, but it has been on the market a while so the price has dropped to about $650 at the time that I am writing this.

DSLR or Mirrorless Camera?

That leads to the question of whether you should get a DSLR or mirrorless camera. This is a tricky question in a rapidly changing landscape.

More recently, camera manufacturers have been creating cameras with an electronic or digital viewfinder. These cameras don't need the mirrors and the prisms inside them which allows

them to be much smaller and a little cheaper. Since they don't have mirrors, these cameras are called mirrorless cameras. They have taken the photography world by storm. Actually, these cameras have been around for a while, but they were essentially toys and weren't capable of great image quality. In the last few years, however, that has changed dramatically. The manufacturers began making cameras that took higher quality pictures even though they had smaller sensors. Then, just a few years ago, Sony blew the doors off the industry by making mirrorless cameras with larger digital image sensors – the same size as are used in the top DSLRs. Starting at that point, mirrorless cameras have been essentially just as good as DSLRs.

So why doesn't everybody buy a mirrorless camera and just ditch the DSLRs? And are the DSLR's days numbered? No, there is a still a pretty good case for DSLRs. Granted, the mirrorless cameras are smaller and don't cost quite as much. That's significant, and may win over a lot of people.

The fact that mirrorless cameras are a little smaller, while nice, is not the game changer some claim it is.

Once you have chosen your camera, you need to buy it. Where to go? The best places to buy, all with nearly identical prices, are Amazon, Adorama, and B&H Photo.

Camera Modes

There are two semi-automatic modes and one fully manual mode that you can use which are each better than Auto mode. With the semi-automatic modes, you are going to choose two variables (ISO and either Aperture or Shutter Speed), and allow the camera to optimize the third variable for you.

You have probably also noticed a bunch of modes on your camera dial that have fancy pictures, like "sports mode" and "fireworks mode." The real reason those exist is for marketing, and helping point-and-shoot users make the transition to DSLR cameras.

Think about it this way: if you were going from a point-and-shoot camera to a DSLR and you didn't see ANY of the camera modes that you were used to using, you might be a bit more hesitant to make the switch. Ultimately, those modes are for the poor souls who don't take the time to fully understand how to use the semi-automatic and manual modes.

Chapter 5: Digital Photography Gear You Absolutely Need

Mostly, what you need will depend on what kind of photography you plan on doing. The equipment needed to photograph a landscape is different than what you need for a portrait. There are some things everyone will need (like a memory card), but after that, there is a bit of a divergence.

Memory Cards

You will need to get a memory card for your camera. Most cameras take SD, or Secure Digital cards these days but some take Compact Flash. These are small, solid-state memory devices that are remarkably stable. These days, memory cards are pretty cheap – you can get a 64 GB card that will hold a huge number of pictures – for about $35. There are a lot of choices though so I will try to narrow things down for you. The primary questions you face is what size, what speed, and what brand of card to choose.

Get a larger card of around 32–64 gigabytes. It will hold thousands of pictures and should be all you need. Some

photographers buy many smaller memory cards (in the range of 4–16 GB per card) rather than one card with a large amount of memory on it on the premise that if the card gets corrupted, you only lose a relatively small amount of data.

Items for Landscapes and Seascapes

Shooting landscapes and seascapes requires that you buy a few other items to do them well. These primarily relate to support and keeping the camera as still as possible. We'll talk about these items next, as well as a few filters you might want.

Tripods

Putting your camera on a tripod stabilizes it so that the camera doesn't move at all during the exposure. Even when you aren't using slow shutter speeds, a tripod helps make your pictures sharper by eliminating any movement. It opens up a world of options for you and is necessary for top-notch pictures. We'll talk more about how that works later, but for now just understand that you will need a tripod in these situations.

Remote Shutter Release

Other than a tripod, the only item that is mandatory for outdoor shooters is a remote shutter release. This is basically a remote control for your camera – it allows you to control your camera without touching it. When the camera is on a tripod, you can therefore increase stability by avoiding any vibrations during the exposure. There are models with cables that connect to your camera and wireless models as well. Both work fine.

Items for Wildlife and Sports Photography

Secondly, if you plan to shoot a lot of wildlife or sports, you will want a way to support your heavy lens. As a sports photographer, whether it is pro or little league, you will spend a lot of time on the sidelines or in the stands with a big, heavy lens on your camera. As a wildlife photographer, you might be awaiting the appearance of a creature, or else anticipating action. In any case, you will want something that helps you support the weight of the camera and lens, lets you stay agile, and that stabilizes your camera during the exposure.

Monopod

A monopod is like a tripod, but it only has one leg, so you have to hold it up. It provides support for your camera and lens. In

addition, it will enhance steadiness a little bit and thus sharpness and overall image quality. It provides some stabilization, but nothing like a tripod. On the other hand, a monopod is easier to move around. You can even use it as a walking stick. Get one if you want some additional support for your lens and you need a little bit of mobility.

Items for Portraits and Pictures of People

For pictures of people, you are going to want a flash unit.

You might think, "My camera already has a little pop-up flash on it. Do I really need a separate, external unit?" The answer is yes. In fact, you should avoid using the pop-up flash on your camera. It is junk. Most high-end cameras don't even have one which should tell you something.

You can get a flash unit rather cheaply if you avoid Canon and Nikon flash units. Those can cost you $500! Instead, you can get a **Yongnuo YN-560 II Speedlight** for about $75. Trust me – it works great. A flash isn't something like a lens that is going to affect image quality. It is just blasting out light, and they all do that pretty much the same. Save yourself some money here and get the Yongnuo.

Flash unit with diffuser cap

While you are at it, get a diffuser. This is a cheap piece of plastic that fits over the top of the flash. It softens the light output of the flash and reduces the harsh shadows that otherwise result. They only cost about $10.

Macro Photography

Macro photography is where you take extreme close-ups of things. Typical examples of subjects for macro photography are insects, small animals, and flowers. This type of photography typically requires a specialized macro lens. These are not cheap.

If you would like to get started in macro photography, however, there is a cheaper and perhaps better way to get started. That way is to buy a set of extension tubes. This is pretty much what it sounds like – it is a tube that attaches between your camera and lens and thereby holds the lens further away from the camera. This allows the lens to focus on things that are much closer to it. They work really well – often better than dedicated macro lenses. Plus, they are not terribly expensive. You can get a set of extension tubes for about $150. If you have any interest in macro photography, I recommend you get one.

Photo-Editing Software

Pictures just don't come out of the camera looking professional. It doesn't matter whether it is a picture of a landscape or a model – it has to be enhanced a bit to look its best. The old photography masters did it in the darkroom. We do it now with software.

The software that came with your camera won't cut it. You need to buy some. The one I want you to buy is Adobe Photoshop Lightroom and it is just referred to as Lightroom. It is made by Adobe which also makes Photoshop. It doesn't matter if you are Mac or PC, Lightroom is the way to go.

Lightroom photo-editing software is essentially a home base for your photographs. It is the best way available to organize your photos. It will allow you to greatly enhance your photos. Many photographers use nothing but Lightroom for their edits. Even if you decide later to get something that will do more heavy-duty edits or specific functions (like Photoshop), most other software interacts well with Lightroom. At that point, Lightroom will still be your home base and you will take it in and out of these other programs. But at the same time, Lightroom might be all you ever need.

The core functions of Lightroom are organization and editing, but it does other things as well. It has other modules that print your photos, allow you to create PDF slideshows, interface with Blurb.com to create photo books, geo-tag your photos, and even let you create your own web pages.

Importantly, Lightroom is very intuitive and all of these functions are relatively simple. Other programs – notably Photoshop – are not. Photoshop will take you months to learn. You can get the basics of Lightroom in a few hours, and you can become reasonably proficient in Lightroom in a weekend.

So How Much Is This Going to Cost?

Ok, let's conclude the gear portion of this book by looking at what this is going to cost. If you want to do the photography contemplated in this book, and you are starting with nothing, and you pay full retail, it is going to cost you $850 for the camera and lens, and then another $150 for Lightroom. Any costs above that will depend on whatever else you buy.

That said, if that price is too steep for you, there are ways to cut back without sacrificing much. The best way to go about that is to take advantage of the way camera manufacturers roll out new models all the time. It seems like every year, there is a new model introduced that is essentially no different than the old

one. Do you know what the difference between the Nikon D5500 that is recommended in this book and the D5300 that it replaced? The answer is "not much." That is not peculiar to Nikon or that model; the same goes for most other new cameras. The changes occur very frequently and are generally minor. And yet, as soon as the new model is rolled out, prices are slashed on the old model. In fact, the price slashing usually occurs before the new model is even out. You can take advantage of this cycle to get real bargains.

The phenomenon addressed above is working to your advantage right now. The Sony A6000 was introduced at $800 with the kit lens. That camera has been on the market for a while now and Sony is no doubt about to announce its replacement. As a result, you can now get that camera and lens for $650. That is not some special deal; that is the price at Amazon, Adorama, and B&H. This is just an example of something that is going on all the time in the camera market so you might as well take advantage of it.

After you buy the camera and lens, you may want to buy a few add-ons. As mentioned, landscape and seascape shooters will need a tripod and a few filters, portrait photographers will need a flash, and wildlife and sports shooters will need a monopod. Prices vary on that stuff, but you should be able to get it for about $250. Of course, if you decide to get a different or additional lens, all bets are off and it will cost a lot more.

Ultimately, if you buy the camera, lens, and gear I recommend, it will probably cost you about $1,000 - $1,250. You can work it to pay a little less. You can also pay a lot more.

Read the Manual

Now that you have your camera and gear, do yourself a favor: Read the Manual.

Most people don't do this, and it is a huge mistake. You don't need to study every word of it, but you cannot expect to master your camera if you don't take the time to at least go through the manual.

Read portions of the manual as you work through this book. When you are working through exposure, read the portion of the manual on the exposure controls. When it is time to set up your camera, read those portions of the manual as well. That will allow you to apply everything in this book to your particular camera.

In addition, take a look at the index of the manual and let it guide you to topics that look interesting. After that, get in the habit of pulling out the manual every time you don't know how to do something or are confused. This will pay huge dividends.

Chapter 6: Elements of Exposure in Digital Photography

There are several classic forms of artistic photography which use aperture to produce desired effects.

Most people have pretty good intuition when it comes to exposure, even if they don't have a clue what exposure is. People will see a picture and say something like, "I think it's too dark and you can't really see any details in some parts." That's a great observation, and whether you realize it or not, you have just made a comment about the elements of exposure.

The three basic elements of exposure are:

- Shutter speed

- Aperture

- ISO

These three elements work together to create the final exposure, or picture. If they're out of balance, your picture could end up looking too light (overexposed) or too dark (underexposed) and

won't be very appealing to the eye. If all that makes you want to stop reading, don't worry. It's easier to do than it sounds.

Now that you have a camera and it is set up properly, we are going to get into the meat of using your camera and talk about how to expose your pictures. Understanding this is what is going to separate you from the vast majority of people.

Understanding Aperture

In its most basic definition, APERTURE simply means a hole through which light travels.

High depth of field makes better sense for landscape shots, crowd pictures, and similar photography where everything in the picture contributes to the whole. But that's only scratching the surface of the uses of aperture in photography.

Most people are surprised to learn that a camera doesn't require a lens – just a small hole – in order to capture an image. They are even more surprised to learn that pinhole cameras are more than just a rudimentary camera. They can produce extremely sharp images and they still have a place in modern photography.

The image is inverted because light travels in straight lines. The light passing through the pinhole is reflected light. When sunlight hits a point on a leaf at the top of the tree, the surface of

the leaf will absorb some of the light and reflect the rest away from it. Some of that reflected light then passes through the pinhole in a straight line from the point on the leaf and strikes the surface at the back of the box.

There is another factor that affects the sharpness of the image. It is the thickness of the material around the pinhole.

Medium Apertures often produce the best quality images when Depth of Field is not critical.

Small Apertures have large f-stop numbers and are preferred for landscape photography. Although the image will theoretically get sharper as the aperture gets smaller, this is not necessarily the reality. Diffraction effects cause some deterioration of the image at very small sizes. Most lenses have a minimum aperture of f/22 but some go to f/32.

The range of effects that can be achieved by varying the aperture isn't as great as what can be done with shutter speeds, but it's an important part of creative photography nevertheless. The range of effects from aperture may be less impressive than those from shutter speed, but they are very important effects. That's why a lot of photographers recommend using the Av mode, where you manually control the aperture (and keep it a constant, reflecting the depth of field effects that you want in the picture) while

letting the camera automatically set the shutter speed, for most purposes.

Understanding Shutter Speed

There is an important concept related to shutter speed called "camera shake." Your photo will be blurred because the camera has moved during the exposure. It is inevitable if you are holding the camera in your hands. We humans are not capable of holding the camera steady for any length of time. We are all trembling and swaying a little bit all the time. Even shutter speeds that might seem fast are slow enough that they can result in camera shake and blurred photos. Full frame sensors are capable of producing a higher-quality image than interline transfer sensors, but require a mechanical shutter to take a picture, making cameras with that kind of sensor necessarily bulkier. Where the highest quality image is desired and compromising this value is unacceptable, a full frame sensor and a mechanical shutter are preferred. Obviously, that's the kind of camera that you want for photography as an art form.

Shutter Speed and Motion Capture

Shutter speed has a number of effects, but the most important one for creative photography is the ability (or inability) to capture motion.

Let's say you're photographing a moving car using a slow shutter speed. You push the button and the shutter opens. Light reflects from the car at its starting position, enters the camera, and triggers a partial image. The shutter stays open. The car moves. Now, light reflects from the car at a new position, and creates another partial image when it strikes the sensor. The car moves again, light reflects from its new position, another partial image is created, and so on. Finally, the shutter closes, and the light reflected from the final position of the car before the shutter closes creates the final image of the car.

Understanding ISO

ISO stands for International Organization for Standardization which is an international organization that sets standardized measurements for all sorts of things. The best way to explain ISO is to take you back to the old days of photography when we used film. If you remember the film days, you will recall that you used to buy film that had numbers on it. Some of the film would say "100," some would say "200," there would be some that said

"400" and the top end was usually "800." That was the film's ISO rating. In the case of 100-speed film, the lower number meant that the film was "slower" film that required more light to expose. That wasn't necessarily bad because the pictures had the least grain in them. On the other hand, the film that was 800-speed was "faster" film that took less light to expose. The faster film had a downside, however, which is that it made your pictures look grainy. So basically, the higher the ISO rating of the film, the less light it took to create a proper exposure but the more it made your pictures look "grainy." You were dealing with a trade-off.

When digital cameras were developed and the manufacturers discovered that they could make the digital sensors more or less sensitive to light, they needed a scale to measure that. They decided to use the exact same scale they had been using with film. Therefore, digital cameras use ISO in exactly the same way as the film days. The only difference is that rather than being stuck with a given ISO for a whole roll of film, you can change it for each shot.

On modern cameras, using an ISO between 100 and 400 will usually result in very little digital noise. An ISO of 800 or perhaps even 1600 will usually be okay, especially if you can apply some noise reduction in your post-processing. Modern

cameras will allow ISOs that are higher than this range, but they are a danger zone to be avoided if possible.

It's a professional body that issues standards for lots of different things, not just photography. Among photographers, though, when you use the term, it's generally understood that you're referring to the light sensitivity originally of camera film, and today of electronic light sensors that take the place of film in digital photography.

The downside of this, though, is that higher ISO settings also produce grainier photographs with more visual "noise." So as with most things in photography, there's a trade-off. ISO 100 is considered a "normal" setting that produces nice, crisp, well-defined pictures with minimal noise. However, that doesn't mean that ISO 100 is the best choice for all circumstances. It's seldom a good choice for dim-light photography as it will render a photo too dark without resorting to very slow shutter speeds or even timed exposure measured in seconds or minutes.

Steps to Exposure_

Choose your ISO.

As a basic rule of thumb, the first element to start with is the ISO. Always try to choose the lowest possible ISO that you can.

We usually start with a 100 or 200 ISO and go from there. If we find that this is not a high enough ISO for the light available in the situation, we can always adjust (unlike the old days with film). The idea is to start with the best quality image we can get without any image "noise." Then, we adjust if we need to. I recommend starting at the lowest ISO I think will work, and then just leaving it alone for a bit. We can always readjust.

Bright Sun or Flash—100 or 200

Light Shade/Cloudy/Window Light—400

Dark Shade/Heavy Overcast—800

Dusk/Indoor/ Lower light—1600 (unless doing long exposures accumulating light)

Many cameras go beyond 1600 ISO. You start to lose significant quality in the image after this point, unless you have very high-end camera.

Ask yourself this question: Is action or depth my priority?

Based on the answer to this question, you will know which setting you should adjust next for your exposure. For example, if you are photographing a fast-moving race car, the answer would

be action. You now know that shutter speed is what controls action as well as light. In this case, you would start by adjusting your shutter speed first. Then we simply move the aperture into place to line up our light meter.

Change the ISO if you can't get what you need out of the aperture or shutter speed.

Even in some outdoor situations where there is a lot of light, very little light is able to hit the sensor during an extremely fast shutter speed. This would happen if the shutter is opening and closing at a high rate such as 1/2000th of a second or above, for example. Even with your aperture open, it may not be enough. In this case, simply increase your ISO to get what you need. Do NOT settle for a blurry picture because you're worried about ISO quality. Remember, you can always go to auto ISO if you are struggling here.

Chapter 7: How to Set Up Your Camera to Get the Most From It

The good news is that many of these are "set it and forget it" controls. That means you can just set them once and then not worry about them anymore.

RAW+JPEG

To set the file type, you will need to go into your camera's menu to Image Quality. Set the camera to take a RAW file and the largest JPEG the camera is capable of making. Your camera might say something like RAW+L. If that doesn't make sense to you yet, don't worry, I will explain it now.

A JPEG is the type of file that is typically created when you take a picture with a compact camera, your phone, or a camera where you didn't change anything. If you just pulled your camera out of the box and started taking pictures, it is what your camera would take. A JPEG is a compressed file that is easily read and shared among computers.

There is good news and bad news about JPEGs. The good news is that the camera manufacturers know how you want your pictures to look. You want them very colorful and sharp. Therefore, when the picture data is turned into a JPEG, your camera will apply a certain amount of processing (increasing the saturation, contrast, and sharpness). This is done automatically to every picture. The picture will generally look a little better as a result.

Furthermore, the processing that the camera adds to the picture when it converts it to a JPEG is done without consulting you. You may want more or less saturation, or contrast, or sharpening than the camera provides. The processing is done according to the camera manufacturer's specifications to each and every picture. There is no change according to your particular taste.

For all these reasons, most photographers set the camera to create a RAW file. A RAW file is pretty much the straight camera data bundled into a file. These RAW files are much larger files (again, about 20–23 megabytes from the cameras I recommend, versus about 4–5 megabytes if you create the largest JPEG the camera allows). They preserve highlight and shadow detail, as well as additional colors to create smoother transitions between tones. RAW files will have no processing to them so you can use

Lightroom or Photoshop to apply this processing however you want.

So, which do you choose? RAW or JPEG? Actually, you don't need to decide. Pick both. Your camera will make both RAW and JPEG files if you set it that way. That will give you the best of both worlds. You will have the best available file (the RAW file) and the processed, compressed, easily transferred file (the JPEG). You won't notice it when you take the picture – but you will end up with two files for every shot you take.

You may be tempted to just shoot JPEGs on the premise that you don't process your photos. That would be a mistake because you might decide to use the RAW files at some point in the future. You want to have the best data possible if you decide to edit your pictures in, say, five years or even longer.

You might also be tempted to forego the JPEG on the premise that you only use the RAW file. On occasion, however, you will be happy that you have a smaller file that you can easily share via email or on the web. The only downside to taking the additional JPEG is that it uses more data, but these days that really isn't a problem since memory is now pretty cheap.

Go into the Image Quality menu and select both RAW and JPEG files. You will get the best quality file possible. You will also have

a JPEG that is already processed and easily transferred. Once you do this, you can leave this setting alone and forget about the whole issue of file type.

The bottom line is that if it's something you want as a possible high quality image and you want to produce the best image quality possible, RAW is the way to go! At the VERY LEAST, use your cameras highest JPEG setting.

It's important to understand what RAW data is. When you take a photograph on RAW, the data is simply a huge amount of digital information that's coming in and recording to your memory card. The data is recording, but it's not actually created into an image at that point. It's just raw unfiltered or compressed data.

When you set the camera up to shoot on a JPEG, the camera converts that RAW data into an image file. For instance, you can email that image right out of the camera or you can work on that image right out of the camera.

You'll find that you're going to be much happier with the end result of your images when you start working those images of the highest quality in software such as Photoshop.

The Mode to Use

On the top of your camera will be a dial with a bunch of letters and icons on it. This is called the Mode Dial. The mode you choose essentially determines how much of the exposure process is automatic and how much you control. There are various options from Automatic (where everything is done for you and you have no control over the process) to full Manual (where you do everything and the camera offers no assistance).

The mode you should use is called Aperture Priority mode, and will be designated by either an "A" or an "Av" on your camera's mode dial. Think of Aperture Priority as a semi-automatic mode. It is easy to use and provides some assistance from the camera in making an exposure. At the same time, this mode gives you complete control over the camera. In fact, this mode is probably used by the majority of professional photographers today.

For the moment, just make the change to Aperture Priority mode even though you may not know how to control the exposure process.

Setting the Focus Point

First, you should tell the camera what part of the frame it should use to focus. You can have the camera automatically pick the focus points for you or pick them yourself.

If you choose to let the camera automatically set the focus points, you need to do nothing. The camera is probably already set up that way. In this setting, the camera will attempt to determine the subject and then set the focus on it. The camera will use presets from the manufacturers to do so. The manufacturers are pretty smart so they will get it right a lot of the time. But the camera will not focus on what you want all the time. The manufacturers cannot possibly anticipate every circumstance you will encounter. As a result, while automatic selection is a viable option for setting the autofocus points, I recommend you set the point yourself.

If you set an autofocus point yourself, use the center point. Who always sets their focus to the right or the left? Nobody. So set the camera to focus on the center point. That will put you in control of the focus.

To set the autofocus point, some cameras have an Autofocus Area button, and some require you to go into the menu. Either way, just go to that setting and move it to manual, then select

the center point. After doing so, you will likely find that this is another "set it and forget it" setting.

Metering Mode

Now you have your file type set up and we have arranged the camera to focus properly. The next thing you need to set on your camera is how it should meter light. That's right. You get to tell the camera what part or parts of the frame to use when metering available light and setting up a proper exposure. You can have your camera do it for you, you can use a lot of the frame, or you can just use the very center of the frame.

When you are just starting out, you should go with the automatic mode and forget about it. This automatic mode is called Evaluative Metering by Canon, Matrix Metering by Nikon, and Multi-Segment Metering by Sony. Either way, it really is just automatic metering of the entire scene pursuant to some algorithm of the manufacturer.

When you set this metering mode, your camera will evaluate the available light of the entire scene in its view. It will weigh some areas more than others (typically weighting the center more than other areas). In doing so, your camera will get the exposure level right a lot of the time. It will certainly get it right much

more than you will by trying to use a spot meter or use any of the other modes.

Your camera is probably already set up to automatically meter light. If so, you need to do nothing. If not, there will often be a button for setting the metering mode, or else just go into the menu and find Metering Mode. Set it to Evaluative, Matrix, Multi-Segment, or whatever your camera calls its automatic mode. Once again, this is a "set it and forget it" setting.

White Balance

Each type of light has a different color value. Fluorescent, for example, is quite cold and blue. However, a photographer usually isn't lucky enough to be working with only one light source. There might be a tungsten light overhead, with the sun shining through a window, and a fluorescent light somewhere in the background.

As you can imagine, those situations can be a nightmare for picking the correct white balance. Luckily, there is a way to set a custom white balance using a simple white piece of paper or anything else that you know is pure white.

Remember to change the setting back to one of the automatic white balances afterward because the custom white balance will only work well under that very specific circumstance.

If it isn't already set this way, just set your camera's white balance to Auto.

If you don't do anything to correct it, your pictures will have weird color casts.

If you just set your camera to automatically adjust the white balance, your camera will do a pretty good job of setting the right white balance for your pictures.

Picture Styles

Picture styles are the processing that the camera applies to the picture when it converts a file to a JPEG. The camera will apply more or less saturation and sharpening to your JPEG files depending on which one you choose. Since you will be creating a RAW file, this doesn't really matter. At least, it is not worth messing around with for purposes of applying processing to a JPEG that you probably won't use anyway. Plus, the standard setting is a good default option.

Chapter 8: The Use of Lens in Digital Photography

You will need longs lens and short lens. Long lenses are good for portraits and zoom shots. Shorter lenses, also called "wide angle" lens, are used for inside shots and landscapes and such. If you can afford it, try to purchase an IS lens for your long lens option.

IS stands for image stabilization. This technology produces slightly sharper pictures of night scenes and also prevents blurring due to a shaky hand holding the camera.

For a beginner, the IS lens may allow you to produce better pictures than you might otherwise be capable of while working on other skills such as medium, lighting, and subject, in addition to marketing yourself. Wide angle lenses don't come in an IS option since the problem of hand shaking is a lot less likely to occur with a shorter lens.

Both wide angle and long lens come in varying mm ratings such as 75-300 on a long lens or 20-35 on a short lens. If money is

less of a hindrance to you, then purchase the lens that offers the greatest mm range.

Otherwise, in order to narrow down your choices when doing research for purchasing equipment, make note of the mm of the cameras used to take pictures that are most like the ones you would like to take.

All you do is twist the ring around the outside of it to zoom in and out until you have the picture you want composed properly. Glass lenses will offer you a much higher quality and are worth the investment of more money. The larger the aperture opening of a lens, the more expensive it will generally be. Some people really need a lens that will help them in low light situations. That small number aperture means more light. More light means a higher cost and better glass. Others may not have that need. It is important to understand your needs and what you want to accomplish before purchasing lenses.

Fixed Lenses Vs Zoom

Fixed lenses are lenses that have no zoom capability. You can purchase a lens such as a 50mm or a 28mm, for example. They are set in their focal length.

For most amateurs, this is not the way to go unless you have a very SPECIFIC reason to buy such a lens. The drawback is this. Although great in quality, you have to purchase several lenses to have different focal lengths available. This means you have to carry much more equipment and also change your lenses much more frequently while photographing. While these lenses are typically of a better quality, the drawbacks usually outweigh the quality differences for most photographers, especially amateurs and hobbyists.

Prime Lenses versus Zoom Lenses

First, we should talk about the two different types of lenses available. The lenses I have recommended that you start with are **zoom lenses**. They are called that because they zoom in and out, or make things appear closer or farther away, and therefore include more or less of the scene before you in your picture.

Prime lenses, on the other hand, are lenses of a single focal length. You'll learn about focal length in a second, but for now, a prime lens is one where the view always looks the same through the lens. Prime lenses typically allow more light through them and, depending on the lens, they can also be a bit sharper. You may want to add prime lenses to your kit later, but for now stick with zooms. They offer a lot of flexibility.

Crop Factor

Unfortunately, focal length gets a little more confusing from here. You may recall that there are cameras with different sized digital sensors. The focal lengths in the chart above apply to "full-frame" cameras, or those with digital image sensors that are the same size as a 35-mm piece of film. Other cameras have smaller image sensors, and cameras with smaller sensors show less of the image. In other words, lenses are designed to reflect light onto a 35-mm sensor, and if the sensor is smaller, some of the reflection will spill over the sides and be lost. It is referred to as a "crop factor." The smaller the sensor is, the more dramatic the crop factor. The first thing to understand in choosing the focal length of your lens is that not all lenses act exactly the same on each camera. This is still a great quality camera, it's just not of as high a quality as a "full frame" sensor camera (the camera on the left). You will notice that the smaller sensor does not reach all the way to the edge like the larger sensor does. What this means is that when you attach the same lens to either camera, the camera does not see through that lens in the same way. Most medium-priced consumer cameras are not full frame.

With this in mind, when shopping for a lens, you need to consider what you want to accomplish with your photography.

A crop factor is not a horrible thing. It is just something you need to be aware of.

Aperture

Lenses with really low f/numbers, like f/2.8 and f/4, let a lot of light into the camera. Prime lenses often have larger apertures and it is not uncommon for their maximum apertures to be as large as f/1.4 or f/1.8. Lenses with large apertures are referred to as "fast glass" in the photography world, and they cost a lot of money. As the maximum aperture gets smaller, the lens doesn't let as much light in, but the lens will be cheaper.

Lens Controls

There are two other controls on your lens to understand. For the most part, these are both "set it and forget it" settings, but there will be times you change each. They are image stabilization and autofocus. You generally want both enabled.

Image Stabilization or Vibration Reduction

Enable this feature and leave it on. It is great. Even if you don't need it in a particular circumstance, having it on will not hurt anything. There are those who say that when you have your

camera on a tripod, you should turn it off. They say that not only is it unnecessary, but for some reason it will also result in a tiny amount of blur in your images.

Manual Focus

The other switch on your lens will enable autofocus (AF) or put the lens in manual focus (MF) mode. Almost all the time, you want your lens to be in autofocus mode.

When you are done with that, switch back to autofocus.

Besides your initial investment with the camera you purchase, your lens purchases will be equal to and possibly of greater value to you in both utility and the amount of dollars invested. You may change cameras every few years, but your lenses, as long as they fit the same system make of your camera, will be around for you to use for years and years.

Typically, the lens that arrives with your camera purchase is a very basic lens of less-than-adequate or even, poor quality. As you grow in your ability as a photographer, lens choices will be the item you will want to invest in more than anything else.

Most lens manufacturers have the following lens focal lengths available in a variety of models. You will notice that there is

usually an overlap of focal length when working with zoom lenses.

If you have been lens shopping, you may have noticed there are many "all in one" lenses. This would be a lens such as the Tamron 18mm-300mm. This can be a great way to keep only one lens on at all times. You never have to bother with changing lenses, and it is much easier to travel with. The quality can be just fine for many photography enthusiasts.

The downside is that these lenses are not available with a very fast aperture opening such as 2.8 and most come starting in the f3.5-f5.6 range which limits you in lower light situations. These lenses may not be as sharp either. But for most, you may never see the difference if you are not printing your images above an 11x14, for example. So, for many, this type of lens is an excellent way to go. Tamron and Sigma make excellent choices for aftermarket lenses that are very consistent in quality.

Using Your Lens

You will probably be starting with an 18–55 mm lens (or something very similar). If you are using this lens on a camera with an APS-C sensor (like the Canon T6i and Nikon D5500), the crop factor will cause it to operate like a 27–82 mm lens.

That will give you a moderate wide angle to a mild telephoto. These ranges are good for a few different things:

- Landscapes and Urban Scenes: at wide angles to capture as much of the scene as possible.

- Portraits and Other Pictures of People: zoomed in as much as possible since this removes certain distortions that occur at wide angles and makes people's features appear more pleasing.

This lens will not, however, be very good for wildlife or sports photography. For those activities, you will need a lens with a larger focal length. I recommend you get something like a 70–200 mm lens if you plan on doing those activities.

In the meantime, the 18–55 mm lens will serve you well. Don't get bogged down with the specifics of focal length. Just keep the autofocus on, the image stabilization on, and set the amount of zoom you want.

Chapter 9: Financial Matters for Digital Photographers

Speculative vs. Non-Speculative_

If you decide that your photography business will consist of you trying to sell pictures you have taken on your own without the direction of another or without having been hired to take those specific pictures, then you are engaging in speculative photography. Many people in this category are stock photographers. Photographers who take pictures hoping to sell them to newspapers and magazines for specific stories are also in the speculative business.

As a speculative photographer, there is no guarantee that you will ever sell the pictures you have taken and, even if you do sell them, there is no guarantee as to when you will get paid for them. As a speculative photographer, you may end up finding a buyer for a picture you took years earlier for your own use or enjoyment, before you even entertained the thought of becoming a professional photographer. One advantage however is that as a speculative photographer, you own the images and

hold the copyright to those images, but you license the right for another person to use those images through a contract.

On the other hand, non-speculative photographers take specific pictures for a specific client who hired them for that purpose. Non-speculative photographers include specialists such as wedding and fashion photographers. They get paid upfront fees to simply photograph the event; the time you are hired to take pictures and you are paid regardless of whether or not the hirer purchases reprints, you are engaging in non-speculative photography. As previously stated, the main benefit of non-speculative photography is that you are sure to be paid for the work you are performing. On the other hand, there is nothing stopping any photographer from doing both speculative and non-speculative work and, in fact, many do both.

Sole-Proprietor vs. Incorporation_

Most professional photographers in business for themselves do not incorporate and are considered sole proprietors which is just another way of saying you are self-employed. Along with your regular income tax forms, you would attach a Schedule C form. This is the simplest form of business because the paperwork is minimal and already closely resembles your general income tax filings. However, sole proprietors should be aware that they are much more likely to be audited than other types of businesses.

This is because the Schedule C is notoriously the most common method used by people to evade taxes. The IRS knows this, of course, and so pays especially close attention to those who file them.

Maintaining your photography business as a sole proprietorship also affords you very little legal protection against lawsuits or divorce. If you use your house as your studio and a client were to have an accident there, you as the sole owner of your business would be liable. Your homeowner's insurance policy would likely come into play in this situation but, because of these liability concerns, insurance companies may automatically increase your rates or simply offer you less than the best coverage as soon as you declare a sole-proprietorship. Also, if you are married and happen to live in a community property state, your spouse owns fifty percent of whatever part of your photography business you conducted while you were married.

Setting up your photography business as a corporation prevents some of the problems associated with sole proprietorships, but doing so is decidedly more complicated. The level of complication depends on the type of corporation you set up. The "S" type corporation was designated specifically for individuals who own their own small companies as opposed to a corporation being owned by a conglomerate.

LLC Corporations_

The third type of corporate designation is the LLC, or the Limited Liability Company. This corporate type is almost never suited for those in their own photography business. It exists for cases where there are a multitude of partners in a business who are not actually involved in the running or working of the company. In other words, they are simply investors. If the people who are actually involved in the working of the company were to be sued for negligence, for example, the other partners would not be liable.

So, incorporating as an LLC is simply a way of getting others to give you money for your company while assuring them that they will not be held legally accountable should anything go wrong. Huge photo studios or chains of photo studios might consider this type of corporation. The average small business photographer need not bother and instead should concentrate on choosing between "S" types and "C" type, depending on the one best suited for his particular situation and needs.

Sales Taxes_

Once your business is up and running, you will hopefully begin to sell pictures or take on clients who will hire you to do photography projects for them. Just as you pay taxes on almost

everything you buy, from boots to bowling balls, and on services you receive from cable installation to car washes, you, too, will have to subject your paying clients to this IRS mandated tradition. There are exceptions and rules to tax sales that you need to be aware of. The first thing you will need is a business license if you plan on selling from your place of work (even if that place is also home) or if you plan on selling to the public. Contact your local tax commissioner's office to find out the exact procedure for your town. Once you have the business license you will also need a resale license. Resale licenses are generally provided by the same authorities that provide business licenses. Again, you'll need to find out specifically for your locale.

If you plan on selling your photos exclusively online, you may not need a business license and you also may not need to pay a sales tax. This will depend on the state in which you live. The laws vary. Your state's Office of the Secretary of State would be the entity you contact to find out the tax and business license laws for where you live.

Once you have your resale license, you need to determine the type of client you are dealing with because this will determine whether or not you will charge them a sales tax. If you are selling pictures to a client whose business is to then turn around and resell those prints, then you do not charge a sales tax. That is,

there is no sales tax when the transaction is between two business entities.

If you are selling directly to a public consumer, then you must charge them a sales tax. The tax will be a percentage of whatever your bill to the client is. The exact percentage depends on the state in which you live. The tax board of your locale will let you know what the sales tax is if you are unsure. If you are selling online and you have determined that your state requires you to collect a sales tax, you need only collect sales taxes from customers who are buying from, or live in, your state. Out-of-state sales transactions are not taxable.

Then there is a special sales tax case that many photographers are subjected to because of the nature of their work. Many photographers do not sell the ownership of their pictures but rather the license, or right, to use them. This is the case, for example, if you are doing freelance business with a newspaper or magazine. In these cases, whether or not you will charge the client a sales tax will depend on your state's particular law. Once again, check with your local tax board.

Chapter 10: Moving Your Photos From Camera to Computer

Getting to Know Lightroom

The program we are going to use, which was mentioned briefly earlier in the book, is Adobe Photoshop Lightroom, better known simply as Lightroom.

What is great about Lightroom is that it is truly a professional grade application, but at the same time, it is simple and intuitive to use. When I say it is professional grade, it is actually used by most professional photographers today. It is as good as it gets for organizing your photos and for performing basic edits. In fact, most serious users find that as they use Lightroom, they come to rely on it more and more and other programs less and less. It continues to get better and more powerful every year.

At the same time, Lightroom is somewhat intuitive to use. That is a big deal in photography because frankly most photo-editing software is not intuitive at all. In particular, Photoshop is famously difficult to get your arms around. Most people find

that it takes them a few months to become even mildly proficient with Photoshop. With Lightroom, that time is shortened to just a few hours.

Another cool thing about Lightroom – and you should understand this so that you understand the program – is that it does not mess with your pictures. By that, I mean that it does not move them around, and also that it does not change your pictures as you edit them. You simply add your pictures to your computer in whatever manner you see fit. Then you open up Lightroom and "import" them which is just pressing a button to make Lightroom aware of the picture. Then, as you make changes to the picture, Lightroom does not actually change the underlying picture. Rather, Lightroom shows you the effect of the changes you are making on the screen and will save those changes in a separate file for later use. That is a big deal because you can make whatever changes you want without changing or degrading the underlying photo. Of course, you can create a new file with the changes baked in whenever you want.

For now, Lightroom will be the only program you will need to use. That might never change, and that is nothing to apologize about since many serious photographers use nothing but Lightroom. So that is what we will talk about next: getting your photos into Lightroom and organizing them.

Organizing Your Photos

You are probably not worried about organizing your photos right now. You may not have many photos at the moment and this doesn't seem like a big deal. Nevertheless, you need to get off on the right foot with getting your photos into Lightroom. At the same time, there is no need to go into great detail about this process.

Putting the Photos on Your Hard Drive

Before even using Lightroom, you will need to put your photos on your computer. Your system will probably default to creating a new folder for each date that you added photos. You might add a word or two after the date so you can see what is on it without opening the folder. So instead of just "2015-10-01" the folder might be named "2015-10-01 NYC trip." Now your pictures are on your computer and ready for importing into Lightroom.

Importing the Photos into Lightroom

You can now open Lightroom and start using those photos. The first time you go to add photos to Lightroom, you will need to create a Catalog to put them in. Create a catalog (File > New Catalog), and name it whatever you want. You will just do this

once as you will put all your photos in the same Catalog. Once you have created that Catalog, it is time to import some photos into it.

What is good about this is that your photos are organized on the left side of your screen in whatever way you would without Lightroom. Lightroom just mimics the structure of your underlying organization.

Collections

Now Lightroom has imported your photos and they are organized on the left side of your screen in the same way as they are placed on your hard drive. That is nice, but what is even better is that Lightroom allows additional levels of organization.

Besides the folders mentioned above, the primary way to organize your photos is through collections. You can create as many collections and sub-collections as you wish.

Putting a photo into a collection does not actually move the photo. It just creates a virtual copy and puts the photo in the collection so that you can have similar photos in the same place. For example, the underlying structure of your photo organization may be by date, as is set forth in the example above, but then let's say you want to put all your pictures of

flowers together. You took pictures of flowers on many different dates so they are in several different folders. You can create a collection named "Flowers" and put all of those pictures in that collection. You could also create sub-collections for particular kinds of flowers as well.

Now your photos will be sorted by date since you originally set up your folders that way. As long as you know basically when you took the photo, you will be able to find it. In addition, you will have collections set up to find pictures by category. So, you can also find pictures by subject matter as well. If you set up collections for events, styles of picture, galleries, etc., your pictures will essentially be sorted by category as well.

Ratings

Lightroom has additional tags you can use to sort your photos. Those are keywords, flags, and ratings. Of these, the most useful is ratings. When you come home with a lot of pictures on your memory card, after you import them, go through the pictures and give the ones that you find interesting and worthy of further consideration a 1-star rating. You can then ignore all the remaining (un-starred) photos. From there, you can add additional rankings however you see fit.

Chapter 11: Using Graphic Design Software to Edit
Your Photos

To edit your pictures, you go to the Develop module of Lightroom. Just click on the word Develop at the top right of your screen. Your picture will be in the middle of the screen, and there will be a set of controls on the right side. You will use those controls on the right to edit your picture.

How you edit your pictures will vary from picture to picture, but there are some tendencies you will encounter and, in fact, some things you will do all the time. For example, recall from earlier that RAW pictures will come out of your camera looking a little flat and lifeless. This is where you fix that, and it will generally involve adding contrast, color, and sharpness. In addition, certain other types of pictures will generally involve similar edits. When photographing a landscape, you will almost invariably be facing a very bright sky and a dark foreground. When photographing a person, you will want to accentuate or sharpen certain details, like the eyes, while smoothing out skin and removing blemishes.

The Basic Edit

Remember that one of the advantages of creating RAW files when you take pictures is that, instead of having the camera apply processing the same way to all your pictures in the way the camera manufacture sees fit, you get to do it yourself. Well, now is when that happens.

When it comes to the basic edit of your photo, there are seven steps. For each of these steps, I'm going to describe the process in a few paragraphs, and then give you a suggested range of values to use. Follow the order presented here. This process may seem a little cumbersome as we go through it here, but once you have done this a few times, it will only take a few seconds.

White Balance

Light has color. You don't always see it because your eyes adjust to it so fast, but it does. Fixing the white balance means neutralizing the color. Remember that when setting up your camera, you left your camera in Auto White Balance so it is doing this for you automatically. While this works well, there are occasions where you will want to change it which is what we will do now.

At the top of the controls on the right, you will see two sliders. The top one is labeled Temp and it is a scale that is blue on one side and yellow on the other. The slider underneath it is labeled Tint and is green on one side and magenta on the other. You can slide these left and right to make the color of the picture look the way you want.

But, you probably just asked, how do you know what is right? The answer is that whatever you like best is what is right. But if you want some help, Lightroom will give it to you. The first way is to start with one of the Lightroom presets. In the dropdown right above the two sliders, you can choose from a variety of conditions. Just pick the one that seems most applicable and then tweak from there.

That method will work just fine, but there is a better way. That way is to use the eyedropper to the left. Click and drag the eyedropper to a neutral-colored portion of your picture. Click on that neutral color. Lightroom will automatically set the white balance based on that.

Contrast

Contrast is like a miracle drug. Increasing it a slight to moderate amount will almost always make your photo look much better. Seriously. Just push that slider up to something between +5 and

+20 and watch your photo become awesome. What you are doing when you increase contrast is making the bright tones brighter and the dark tones darker.

As mentioned previously, RAW files are generally a little flat. Increasing the contrast will fix that. Forego the increase if your photo has very light and very dark tones that a contrast increase would push into pure white or pure black. But for all other times, bump up the contrast a little bit.

Colors

Next, you are going to make your picture slightly more colorful. This is another move you will make nearly every time to punch up your RAW file.

You might immediately reach to increase the saturation – and there is a Saturation slider in Lightroom – but you should actually leave that slider alone. It is a very blunt instrument that will wreak havoc with your colors. Instead, increase the colors in your picture by using the Vibrance slider which is just above the Saturation slider. A slight to moderate boost is all you need. Most of the time it will be between +5 and +15.

Vibrance is better than saturation because Vibrance works the hardest on the least saturated colors. Saturation, on the other

hand, boosts all colors equally. It tends to make already saturated colors look psychedelic. If you do use the Saturation slider, make only a very minor increase.

Removing Spots

Lightroom makes it really easy to remove spots and other small, unwanted items from your pictures. Just click on the Spot Removal tool. Then go to the spot or other small item and click on it. Lightroom will take care of it.

Make this part of your workflow even where you don't immediately see spots or other unwanted items. Zoom in and move around your picture, on the lookout for any small imperfections. Use the Spot Removal tool to remove them in the method stated above. When you are done, you will be surprised what a big difference removing these small items makes.

Cropping

Your camera shoots at a 3:2 ratio, meaning that if you create a photo that is 6 inches long it will be 4 inches tall. Does that mean all your pictures need to end up in that ratio? No way.

Use the Crop tool to make your picture look its best. That might be a completely different aspect ratio than what you started

with. There is no magic to a 3:2 aspect ratio. In fact, many standard printed sizes won't work at 3:2. Standard sizes like 5x7, 8x10, and 11x14 will not divide evenly into your camera's 3:2 aspect ratio. Therefore, there is no need to feel restrained to the 3:2 ratio pictures that your camera creates.

The Crop tool is also your second bite at the apple when it comes to composing your pictures. Take full advantage of it. No matter how much you fuss over the composition in the field, you can almost always improve it when you have time to sit down at your computer.

Cropping is easier and better in Lightroom than any other program. Just select the Crop Overlay which is designated by a rectangle on the top right of your screen, or press R on your keyboard. You can constrain the crop to any aspect ratio you want, or else leave it unconstrained. Just scoot in the sides or the corners to crop the picture.

This is a good time to make sure your picture is level as well. That is also done through the Crop tool in Lightroom. Move your cursor just outside the picture, then click and drag up or down. Lightroom will change the angle of your picture and also provide you with guidelines. Definitely use this feature when the horizon line is in your picture, but it is worth checking in other contexts as well.

Sharpening

Lightroom has three tools to help you make your picture appear sharper.

The first one is Sharpening. Scroll down to the Sharpening section and push the Amount slider up to about +50. If you find that it is causing a noise problem, increase the Masking slider just below it to somewhere between +10 and +20.

The second tool is called Clarity, and it will have an even more significant effect on your pictures than Sharpening will. Push the Clarity slider to the right somewhere between +5 and +15. Be wary of going over 20.

Lightroom recently added a new Dehazing tool. This was apparently created to remove haziness from your picture, but it can also be quite effective at adding local contrast and sharpening to your photos. It is located near the bottom of the Develop module tools. To add a little extra sharpness to your photos, push it to the right to about +10.

Noise Reduction

As mentioned previously, when you take pictures with a high ISO, your picture will have digital noise in it. There is perhaps

no better tool than Lightroom for removing noise. It is simple to use and powerful.

Just scroll down to the Noise Reduction sliders and move the Luminance slider to the right however much is necessary. You can see a close-up of the effect in the small window just above.

How much is necessary? Of course, it depends. For just a little noise, move the slider to about 10-15. For heavier noise, go up to 20. Be wary of going much above 20 because applying noise reduction will start to remove detail from your photo.

Targeted Adjustments

Notice that each of the adjustments we have made so far has affected the entire picture equally. You can also make most of these adjustments to particular parts of your photo. Do that through the use of the Adjustment Brush. Just click on the brush tool icon on the top right of your screen, or press K. When you do so, a panel will open up just below it with all the sliders you can change using the brush. Below that, you have additional sliders to change the size and feathering of the brush. You'll learn more about using the Adjustment Brush as we get into specific edits, but for now I just wanted to introduce you to it.

Speaking of specific edits, let's get into them now. We'll start with the standard outdoor photograph, like a landscape, seascape, or urban scene.

Editing Outdoor Photos

An insanely high percentage of landscape, seascape, and other outdoor photography suffer from the exact same problem: a sky that is too bright and a foreground that is too dark.

Fixing the Sky

First, let's fix the sky in your picture. What you need to do is reduce the brightness of the sky while maintaining contrast. There are two simple steps for doing this:

Decrease the Highlights: Pull the Highlights slider to the left to reduce the brightness of the brightest portion of the picture which is invariably the sky. Don't worry about the value – just do it until you can see detail in the sky. Don't push it too far as you want at least a portion of the sky to be white which will contrast against the deeper blue you will create in the next step.

Decrease the Luminance of the Blues: Next go down to the Hue/HSL/B&W panel. You will see several sliders of different individual colors. Make sure that it is set to change luminance,

and pull the Blue slider to the left. That will make the blue portion of the sky darker. Again, there is no set value, just pull it until the sky looks its best.

What you are doing here is first reducing the tones of the sky so that you have detail in it. After that, you are darkening the blues which creates some nice contrast in your skies. At this point, your sky should look much better.

Fixing the Foreground

Now we are going to fix the foreground which is too dark. Once again, there are two simple steps to do this:

Decrease the Blacks: Pull the Blacks slider to the left a little bit until the washed-out look that occurred after the last step goes away. The amount varies, but you'll find that often a decrease to -10 to -15 works well.

Now your foreground should look good as well. Brightening the shadows brought out the detail in the sky. Reducing the blacks increased the contrast of the foreground and removed the washed-out look.

After you complete these steps, your outdoor picture should look much better. Remember that these steps are in addition to the basic edits made in the previous section. After completing these

simple steps, which only take a few seconds, your picture should look dramatically better.

Editing Pictures of People

Now let's look at another common photo – the portrait or standard picture of a person or group. Editing this type of photo is all about making sure your subject stands out and enhancing certain details. It doesn't have to be an actual formal portrait for you to use the techniques discussed here. And you are not trying to create a glamour shot. These are just some edits to use whenever you take a picture of a person that you want to enhance a little bit.

Standard Edits

First, perform the standard edits discussed at the beginning of the chapter. If your photo would benefit from being cropped, or there are spots to be removed, go ahead and do those things first. After that, make the changes to white balance, contrast, and sharpness addressed earlier. Just doing these basic edits will make your photo look a lot better.

Adjust Brightness Values

Your subject should stand out against the background. This virtually always means that you want your subject bright and your background a little darker. To achieve this effect, use the Adjustment Brush to increase the tones and contrast of your subject.

To adjust the brightness of our subject while leaving the rest of the picture alone, Lightroom provides the Adjustment Brush which was introduced earlier in this chapter. Before selecting the brush, however, zoom in on the area you want to change. To do that, press Ctrl + =. Then use your mouse to move the field of view where you want it.

After you do this, select the Adjustment Brush at the top right of your Develop module tools by clicking on the icon on the top right of your screen or by pressing K. When you do, you will see a whole new series of sliders come up. These adjustments will only affect the area you select with your brush. There are a number of sliders you can use to affect the brightness values of your subject. If you need to make a drastic change, use the Exposure slider. Otherwise, try increasing the shadows and whites while decreasing the blacks.

Use the brush to paint in the desired effect wherever you want. Don't worry if the effect isn't exactly what you want, or if you paint over where you intend for it to apply. You can change the sliders after you paint. You can also press the Alt key as you paint and it will remove the effect from the image. After you have painted where you want the effect to apply, tweak the sliders mentioned above until your subject stands out the way you want.

Sharpen Details

There are certain details of a photo that you will want to stand out. Usually this is the eyes although it can include other features as well. In this section, I will show you how to do that, and how to enhance these features at the same time.

Let's start with the eyes. To enhance the eyes, you will use the Adjustment Brush again. Zoom in on the eyes (press Ctrl + =) and select the Adjustment Brush (press K). You want the eyes to appear sharper so you will increase the Clarity and Sharpness controls in the Adjustment Brush sliders right away. But you can also make the eyes stand out by increasing the contrast. Further, increases to the highlights and saturation will make the eyes appear a little brighter and more colorful. Remember that you can paint on the eyes with the Adjustment Brush and then

adjust the sliders after the fact so that you can see the effects of the changes you are making.

After that, you can use a similar technique to enhance other parts of the image. A good candidate for changes is the teeth and mouth. Increases to whites or highlights make the teeth brighter, and an increase in saturation will make the lips stand out better.

Of course, while there are parts of the image you want to stand out, there may be parts you want to eliminate. We already talked about the Spot Removal tool, and this can be used to remove any blemishes. To add smoothness to the skin, you can use the Adjustment Brush and decrease the clarity. Apply it to portions of the skin to reduce wrinkles or other effects of age.

Vignette

Finally, to make your subject stand out a bit more, consider adding a vignette to the picture. This will darken the corners and edges of your image. Lightroom makes it incredibly easy to do.

To make a vignette, scroll down to the Effects controls in the Develop module. You will see controls under that heading for Post-Crop Vignetting. Pull the Amount slider to the left to

darken the corners and edges of the photo. You can control the size and feathering with the controls underneath as well.

Chapter 12: Displaying Your Photos on the Web

By now you have probably taken some pictures. Hopefully you have them on your computer and organized in Lightroom. You don't just want to let them sit on your hard drive where no one but you can see them. That's a waste. This chapter will help you showcase your best pictures online where the world can see them.

To me, this is a highlight of photography. It is sort of like the culmination of everything you have done. You researched the location and found the best shot. You used your new skills to properly compose and expose it. You edited your photo in Lightroom so now it pops. Now it is time to show it off a little bit.

I know lots of people who take little or no effort to show their work. That made sense several years ago when you had to spend a lot of money or know how to code to create a website. Now, it is very simple and cheap to display your work.

Displaying Your Best Work

Notice that we will be talking about your best pictures here. No matter how you ultimately decide to display your pictures, the first thing you will need to do is limit which pictures you display. You don't just put all your pictures in a gallery. In fact, if you are displaying more than one or two pictures from a full day of shooting, you are probably displaying too much. A professional or serious amateur photographer may take 1,000 pictures in the hopes of getting one great picture. Ansel Adams famously said that he hoped to get one picture a month.

If you take a bunch of pictures of the same thing from different angles and perspectives, you just need to pick the best one. Do not display three because you cannot decide. You simply must decide. The other pictures aren't going anywhere so you can always change your mind later.

Places on the Web to Display Your Photos

Once you decide to display your photos online, the question is where you should display them. You may not want to undertake building your own website right away. Rather, you might want to start with a free community to post your pictures and build from there. In this chapter, you'll see the options from cheapest and simplest to most expensive and time consuming.

Flickr

If you have not put your photos on the web at all, start by setting up a **Flickr** site. This is free and easy to use. You just sign up for an account and start uploading your photos. From there, you can organize them into albums. It is all done through a drag-and-drop functionality. You will be up and running in a matter of minutes.

There is also a social component to Flickr. You can mark others' pictures as Favorites and follow other photographers you like, and others can do the same to you. You can also join groups of photographers with like interests and submit photos to those groups. It is a good way to get involved in the world of photography.

Flickr might just be a place to get you started. You do not get your own domain and customization is extremely limited. It is also not known as a place with high-quality photos (although there are some great pictures on there). Still, it is free, and a great place to get started while you build up a portfolio of great pictures.

500px

Once you have been shooting for a while, upgrade to **500px**. 500px is basically the same as Flickr, but better. By better I mean that the pictures are of much higher quality.

500px has all the same advantages and disadvantages as Flickr. It is free (although there are paid upgrades, which you probably will not need). It is an easy to use drag-and-drop functionality. It has groups and a social component. At the same time, you do not get your own domain name and it is probably not the final solution for your online presence.

Besides having pictures of much higher quality than Flickr, there is one key way that 500px is different, and that is the social component. When you upload a picture onto 500px, it is placed into a pool of pictures called "Fresh." Others see the pictures, and your picture gets points based on the number of people that make your photo as one they like or as one of their favorites. The more people like it, the more points it gets. If your picture gets up to 70 points, it goes into a pool of pictures called "Upcoming." That allows more people to see your photos. Finally, if your picture gets 80 points, it goes into a pool of pictures called "Popular." After a day, you lose some of your points to make sure that photos get rotated. It is fun and addictive.

Portfolio Site

Once you have some pictures worth displaying, and have a little time to set up a website, you can create your own website. If this sounds daunting, it is not. You do not have to know any code and it does not cost much money either.

There are many online services that will help you set up a good-looking website to display your photos. The two best are **Squarespace** and **SmugMug**. You will get your own URL, which will be customizable to your own tastes, but fully hosted by the service.

WordPress

If you plan to do more with your website than just display pictures, create a **WordPress** site. This is particularly true if you plan to do any blogging in conjunction with your photography. You can also use a WordPress site as the blog portion of another website. WordPress has traditionally been the type of site used for bloggers, and it still excels at that, but it is now much more expansive. I have read that over 25% of all the websites in the world run on WordPress, including those of many major corporations.

WordPress is free, but you will have to host the site. There are a variety of services that will do that for you for just a few dollars a month. After that, you pick a theme which determines the overall look and feel of your site. There are countless themes available, and many are free. Once you set up your theme, you just create content and then post it to your site. It can be remarkably simple, or you can dive as deep into it as you want.

How to Create Your Portfolio Site

Once you decide to create your own online portfolio, what should you actually create? How many pages should the site have? How many galleries should you include? And how many images per gallery?

Let's set up the page architecture first. All you need are four pages: a front page, an about page, a galleries page, and a contact page. These are easy to design and configure in SmugMug or Squarespace (and other services as well). There will be plenty of examples to choose from. Check out how other photographers have done this as well.

Once you have these pages created, you will need to upload some photos. Assuming you have not been photographing very long, start by picking your 20 best pictures and uploading them.

As you create more great images over time, keep adding them to your online portfolio.

After a while, you will probably end up with enough pictures that it makes sense to separate them into multiple galleries. You will usually separate them by category or event. You might also include a "best of" or favorites gallery. That allows you to put your best foot forward to people that come to your site. You'll be surprised at how quick people are to leave so you need to make it compelling for them to stay. Putting your absolute best work front and center will help that happen.

Building up your site necessarily means adding new pictures and galleries to it. This should naturally happen as you take more pictures. Don't try to go too fast. It is also important to make sure you remove pictures as well. This is a major key to strengthening your portfolio. If you are adding new strong pictures and occasionally removing the weakest pictures, your galleries will naturally improve.

Chapter 13: Printing Your Photos

When it comes to displaying your photos, the other option, albeit one that is used less and less these days, is to print your photos. It gets said all the time, but it is true, that there is just something about having a print that you can hold in your hands. The print means that you have turned all the knowledge and effort you put into making the photograph into something tangible that you can keep for a long time. As such, you should print some of your best photos from time to time.

But it is difficult to know where to start when it comes to printing. Should you do it yourself or send it out? If you are going to have a lab do it, then which one? And what kind of paper should you use in any event? If you are going to print the photo yourself, you can get lost in an array of printer profiles and other settings. Hopefully this section will demystify the process for you so that you can print your photos with confidence.

Having Prints Made for You

The first decision you will face is whether to send out the photo or do it yourself. There is no right answer here and most people will do it both ways from time to time. Personally, if it is a small print, I will do it myself, but for larger prints, I will send it out.

Deciding Where to Have Your Print Made

Once you decide to have a photo lab make your print for you, you may wonder where to send it. I did. In fact, I ultimately wondered about it enough that I decided to do a test of all the major online photo labs. I sent each of the major online photo labs three different pictures and had them each make prints of the three pictures. I then measured print quality, price, and other factors to determine which labs were best. I ultimately determined that the top-tier photo labs were Bay Photo, Pro DPI, and White House Custom Color. Use any of those and you will be fine.

Preparing Your File for Printing

Before sending your file to the lab, you will need to make sure your file is ready to print. The problem is that all monitors are not set up the same way so pictures appear different in different

monitors. Further, how your picture appears in a monitor does not necessarily translate well into how it will look in print. Typically, prints end up being much darker than what you see on your monitor.

Rather, just take a few commonsense steps to make sure that your photo will look close when you have it printed:

- The first thing to do is to turn down the brightness of your monitor. Monitors are routinely set by the manufacturers to be very bright because everyone likes bright monitors. However, that is not accurate and when your picture is printed, it will therefore look very dark. If you keep your monitor brightness turned down, then you will edit your pictures to make them the proper brightness.

- The next thing to do is check that the histogram of your picture lines up with what you think the picture should look like. In other words, if you think there ought to be tones across the whole histogram, make sure your histogram actually looks that way. If the histogram only shows tones in the lower parts of the scale, then your picture will not print what you see on your monitor. In that case, you will need to increase the exposure to make

the print look right – regardless of how the print looks on your monitor.

Taking these steps should make sure you receive a good print back from the printer. You will usually be surprised at how good a job they do and how good your picture looks in print. It is also not that much money to have someone else do the printing for you. Give it a try!

How to Easily Make Your Own Prints

The other option, of course, is to make the print yourself. This has become a much more viable option over the years. Printer quality has greatly improved while at the same time the prices of photo printers have come down dramatically as well. You can now purchase a quality photo printer that will make prints up to 13 x 19 (A3+ or 329 cm x 483 cm) for just a few hundred dollars.

Paper Choice

The first and perhaps main question you will face when making a print is what type of paper to use. There are literally hundreds of different kinds of paper and you can get completely lost in this subject. When starting out, I find that it is helpful to match the paper with the printer. For example, if you use a Canon printer, you will find it works well with Canon paper.

Even when you decide on a brand, there are many types of paper to choose from. The three major categories are:

- Glossy, which looks really crisp and slick, but sometimes produces a glare in the photos,

- Matte, which has no problems but is the dullest type, and

- Luster, which is somewhere in the middle.

There is no right answer here, but I generally use Luster. It is generally thought to have a little more contrast and saturation than matte paper, but without the glare of glossy paper. Start with Luster, but give the others a try as well.

Using Lightroom to Make Prints

It will probably come as no surprise to you to learn that we will be using Lightroom to make prints. That is not just because we have been using Lightroom for everything else (although that is partially the case), but also because Lightroom makes printing extraordinarily simple and easy. There is a dedicated Print module we will use and walk through various choices. The remainder of this chapter will walk you through the process, step by step.

With the photo you want to print selected, go into the Print module by clicking on the word Print on the top right of your screen. You will now prepare that photo for printing.

Page Setup

Start with the Page Set Up button on the bottom left side of your screen. Here you will choose the size and type of paper you will use. Be sure to select the printer and paper first because this selection will drive other choices you will make later.

Layout Options

After setting up your page, the remainder of your choices will be on the right side of the print module. The meat of your choices will be in the bottom panel (labeled Print Job) which we will get to in a second.

Print Job

At the bottom panel labeled Print Job, you reach some selections that will really affect the way your photo appears. Those are:

- **Print Resolution:** for most printers this will be between 240 ppi and 300 ppi. Check your printer to see what it recommends.

- **Media Type:** here you will tell Lightroom whether you are printing on matte or glossy paper. Those are the only two options.

- **Print adjustment box:** At the bottom you will see a print adjustment box which is very important for making your prints match your monitor. Make test prints and note the relative brightness or contrast. Increase the brightness with the slider presented here until the photo looks right. What is great about this is that once you set the brightness and contrast levels, they will remain in place for future photos as well.

You have now reached the bottom of the Lightroom print module. You should be ready to make your print. Go ahead and hit the Print button and see how it turns out.

Chapter 14: Advertising Your Digital Photography_Services_

No matter how good a photographer you are, no one will hire you to do projects for them if they do not know that you exist. As is the case with every business, you must advertise your existence or close up shop. Advertising is most critical when you are first getting started. As the years pass and your reputation builds, you will get more and more clients coming to you because they heard about you from other satisfied customers or because they saw your work somewhere. Even then, you will want to be consistent about advertising but, depending on just how successful you become, it may not need to be the forerunning concern of your business that it should be when you first open shop.

General Advertising_

Your most basic form of advertising will and should be through your local town or city's yellow pages. This may seem strange advice considering the ubiquity of the Internet, but people actually still use the yellow pages and use them extensively. This

is especially so for consumers who are searching for services that, by their very nature, need to be provided locally. A couple getting married in Missoula will not hire a photographer based in Miami to take pictures of their wedding. The Internet may be a great place to find photographers but the Missoula phone books will be a quicker way to narrow down the choices to the local possibilities.

Wedding photographers should also seek out the places that engaged couples would visit in planning the celebration of their nuptials and get permission to post flyers or leave business cards advertising their services. This includes tuxedo rental outlets, catering companies, and perhaps most importantly, bridal gown shops. Most hometown newspapers have a society section where they announce engagements, weddings, and anniversaries, usually on a weekly basis. Ad space for those pages are sold specifically to businesses that cater to people involved in such events including, of course, photographers. Similarly, pet photographers will want to advertise at pet supply stores and veterinarians' offices and portrait takers might consider contacting school districts in their area.

Even photographers whose specialty would not be in need by the vast majority of the public should advertise in the yellow pages. Insurance companies or real estate mortgage holders needing photographers to document their properties may simply look in

the yellow pages under "Photographer' to find generalists, and think how pleased they would be to find your name and a notation that you do exactly the type of photography that they are seeking.

Internet Advertising_

It is wise to advertise in places that are specific to your geographical locale but it is equally as wise to advertise on the Internet. Though people still do use the yellow pages and still find photographers through posters in stores and other public places, the number of people who automatically let their fingers do the walking across their keyboards to find providers of services they need is just too large to ignore. And it is growing by leaps and bounds as you no doubt know. In addition, the population of people who use the Internet as their primary source of purchasing products and services is considerably skewed to the young. It is wise business sense to make yourself known well and early to this population.

In order to set up a website, you will need a service provider. Don't be nervous if you don't know anything about building a website. The company from which you will purchase a web address will provide you with relatively easy-to-follow instructions and tools to build a rudimentary site. They will also provide the means through which you can enter the keywords

related to your business that will allow your website to pop up (along with a list of others) when an Internet user types in a search term.

If you are willing to spend the additional money, you can also pay to have your website among the top sites that will appear in any given search for which your keywords are entered. Of course, the more you are willing to pay, the more visibility your site will be given. For those photographers whose only or primary means of sales will be on the Internet, it makes sense to spend as much as you can to get the best returns, providing of course, that what you spend does not ultimately cut into your profits so much that they are virtually non-existent.

On the other hand, the cost of this, as well as general advertising, can (and should) be considered when fixing the price for your prints in the first place. For the photographer who wants to advertise on the Internet, but knows ahead of time that he or she will only take on local projects, it is imperative to put in the name of your state and hometown in your list of search terms as many people will use geography to quickly narrow down their list of possible photographers from whom to choose.

Chapter 15: Legal Considerations for Digital Photographers_

Model Releases_

A model release, which is a document signed by the person who is being photographed or the person who owns the property that is being photographed, stipulates the use and/or limitations of use for the picture and notes any compensation that may have been given. The first thing to know is that, despite the name of the document, it is not intended only for professional models of the runway variety. Anyone who is the subject of a picture is considered a model.

The other thing to know is that the model release is not something that is required by any kind of law. The reason they are used is that despite the lack of a law requiring a photographer to get a release, not getting one can open up the photographer to civil lawsuits brought by the model in the photograph. The model is the only person who can object to the use of his or her image. Note, however, that minors cannot sign

model releases so permission to use their image must be obtained from a parent or guardian.

Getting a model release in any and every situation may be your safest course of action, but there will be situations where getting a release is not possible. There are also situations that do not require a release. Since model releases are not required by any law, this last statement should be read to mean that there are situations when, despite the fact that you didn't get a release, you are not likely to be hauled into court and sued by the photo's subject. Then there may be those sticky situations where you will not want to get a release because you are reasonably certain that permission will not be granted for use of the photograph.

Although there is no law mandating that you get a model release, there are laws which make it very easy for photographers to be sued if they do use pictures without a release. The most common and clearest reason for needing a model release is when the picture taken will be used for commercial purposes such as selling, advertising, promoting, or supporting a product, a political viewpoint, or religious idea. This is a where model releases are always needed, or at least highly advisable.

Model releases are not needed when the subject of the photograph cannot be identified. Most of the time this will be

quite obvious: either you can or you cannot make out the face or other identifiable features of the person in the photograph. But beware, because this standard is subjective.

There may be little stopping a person from filing a suit claiming they are the person in the photograph (whether they are or not) and claiming that their lawsuit is reasonable because they did not sign a release and did not receive compensation. This is a far-fetched scenario; however, if it does occur, you should be aware that the decision as to whether or not the person is identifiable will be left up to a court and will probably cost you some legal fees. Again, when it is possible, the best option, and the way to avoid a situation such as this, is to get a model release even if you know the model will not be identifiable.

Model releases are also not required when the picture is intended to be used for news stories. This is because of the First Amendment right of free speech. Newspapers, magazines, and even school textbooks can use photographs of people who are clearly identifiable, without obtaining a release for the photo. Of course, the photo in the newspaper or magazine must accompany the news story (or be the news story itself) and not be used in an advertisement.

Property Releases_

Pictures of people may require model releases. When pictures are taken of property, the release needed is called a property release. Determining whether a property release is needed is similar to determining whether a model release is needed. The main issues are whether the property is identifiable and what the intended use of the photograph is. A picture of a private home or business taken from a public street and meant for non-commercial use does not require a release, even if the property is identifiable. A picture of the same property taken on the premises (which would be private property) requires a release regardless of the use. As a matter of fact, permission in this case is usually needed even before taking the picture as it would be required to gain access to the property in the first place. Otherwise, this may constitute a case of trespassing which would make any use of the picture illegal.

Trademarked Images_

Trademarks are used to identify a specific brand of product and are usually logos such as McDonald's golden arches, artwork like the Mona Lisa, or buildings such as the Empire State. Trademark holders have the right to limit the use of their trademark and have the sole right to allow their use. This applies

to photographers as well. Taking pictures of a trademark for your own personal, non-commercial use is perfectly legal, of course. But once that photograph is meant for display, whether or not that display is for a commercial reason, you need to obtain permission that goes beyond a simple model or property release. Just as in the case of model or property releases, however, there are exceptions for use of the images of trademarks. If the picture of the trademark is intended for news, editorials, or satire, then this use is considered protected under the First Amendment and permission is not needed.

It is also common for certain trademarks holders to not pursue cases of illegal use that they may have because it is simply not worth it. Pictures of the Empire State Building, for example, are so ubiquitous and are worth little compared to the cost it would take to direct legal action against a photographer who failed to obtain the proper permission for its use. Still, as in the case of model and property releases, photographers should obtain permission for use of images of trademarks, whenever possible, because it is better to be safe than to be sorry. The United States Patent and Trademark office has a search link on their website that allows you to quickly determine whether or not an image you have photographed is trademarked and thus might require permission to be used in anything other than a private setting, for news, or for art.

Copyrights

Copyrights differ from trademarks in that a copyright is something that a photographer can obtain to prove ownership of his own pictures. Photographers, like writers and other artists, can give permission for their work to be used by others. This permission can be in the form of a contract which stipulates that the photographer will be paid for use of the picture or pictures. Photographers can also give permission that their work may be used for free. But even though permission is granted for use of the picture, the ownership of that picture is still retained by the photographer, unless he or she specifically and legally transfers his or her ownership to someone else. In this case, the copyright and all that it entails would transfer to that new owner.

You may not automatically own the copyright to your photographs if those photographs were taken under a work for-hire situation. For example, if you work for a magazine or newspaper, and taking and submitting pictures is part of your job description, the likelihood is that both the pictures and the copyrights to those pictures belong to your employer. That would mean, once you left that employer, you would have no right to use, sell, or distribute the pictures you took under their direction.

Most photographers do not register their work. And many illegal uses of images are not even known to the original photographers. So, for many end users, it actually makes more sense, both financially and time-wise to simply infringe on a photographer's copyright.

But if your work is legally copyrighted and someone infringes on that copyright, you could be in for a huge windfall. The law is set up so that the copyright holder can collect not only the legal fees he or she spent defending his or her copyright in court, but also up to $150,000 per image used without permission. A new law even provides additional compensation to the copyright holder if the infringer removed the copyright notice from the image. The copyright logo, therefore, should always be on your images, even though the logo is not required to be present to make your copyright legal and official.

In order to copyright your work, check the United States Copyright Office's website for information. There are different forms, procedures, and deadlines, depending on whether your image is published or unpublished, the date of publication, or if it is a single image or a collection of images. There are also different forms that are acceptable to submit copies of your work to be copyrighted. Sometimes film negatives will be acceptable while other times your best bet might be to have a video copy of your images.

Chapter 16: How Much Should You Charge?_

Knowing how to properly incorporate and pay sales taxes is good for keeping the IRS off your back, but the average beginning professional photographer struggles with the issue of just how much to charge for their services and for their prints in the first place. What you will charge, and just how you will go about it, depends on what kind of photography sales you are involved in. There are three basic types and it actually is most common for photographers to be involved in all three. There are art sales, commercial licensing fees, and client assignments.

Art Sales_

Art sales are when you sell your print – sometimes frame included, sometimes not – and the buyer's objective is to have it to look at. They may want to look at it in their home or their office or art gallery, but the basic premise is that art sales is the sale of decorative photography. For some photographers in the business of selling prints for art, the question of pricing is taken out of their hands because they sell through galleries, distributors, or agents who represent them.

For the do-it-yourselfer, a basic step to take is to visit an art gallery and find photographs that most closely match the style you produce and see what the selling prices are. Once you do that, you will have a general ballpark idea of how high or low you may want to set your prices. This is especially a good step to take if you are planning on selling your work locally as opposed to through the Internet. Prints will sell at different prices, depending on what part of the country you are doing your business.

There are two caveats to this way of setting prices for your prints, however. First, the prices you see at galleries or other distribution points will include a certain percentage for the gallery and distribution center owners. These percentages will vary and it isn't likely you can find out what the percentages are just by asking. The second caveat is this: pricing art for sale to collectors and decorators isn't the same as pricing other products. Lowering your prices won't necessarily make you more sales. This is because unsophisticated art buyers are the price-conscious ones. They will tend to nitpick about your price, no matter how low it is, and then they tend not to buy anyway.

On the other hand, serious collectors and art patrons are less sensitive to price as they are more aware of quality and value, not to mention they tend to have deeper pockets. Pricing your art reasonably but out of the range of the unsophisticated

consumer will drive many of them away. What this will do is free up your time to deal with the higher end consumers who, though smaller in number, will be more likely to purchase your prints if they are good in quality and technique.

Licensing Fees_

For those who sell the license to use their images, there are actually computer programs designed to help you determine how much to charge. These will not be helpful in all cases and, in fact, often fail to consider some serious factors. For example, these programs tend to deal with general magazines, often national in nature. Those photographers who specialize in a highly specific field might not be getting any help for pricing, even if the client they are dealing with also has a circulation of 30,000 subscribers. Thirty thousand subscribers to a fashion magazine is bound to mean something totally different in terms of photograph license fees than thirty thousand subscribers to an electronics journal. The programs may also provide a range of prices, as well as an average price for certain images, but this does not tell the professional photographer if that average is a result of the bulk of images being licensed at the extremes of the ranges.

Nevertheless, they provide a starting point for the professional photographer who is wondering what price to quote to a

magazine interested in using an image for a news story or for an advertisement. One relatively decent program is called Fotoquote. This program uses price information and statistics in the photography industry from the previous sales year to determine their numbers so at the very least they are up-to-date.

Direct Client Sales_

This is the most common type of sale that photographers engage in. The photographer is hired specifically to shoot pictures for a predetermined use. This is the kind of sales that specialists such as wedding photographers, school portrait shooters, and others are involved in. Even these sales, however, come in two different types: general direct sales and work for-hire.

Where the Difference is Most Important is in Who Owns the Images

Most photography specialists will set up shop and then have customers come to them to have pictures taken. The pictures are taken and sold to the client, but the photographer actually retains the copyright to those images. In other words, what the photographer sells to the blushing bride and groom after their wedding are not the wedding pictures, but a license to use those pictures as they see fit. Usually, of course, this means for albums

that will become dusty in a few short months or for websites promoting the new and blissful union. The photographer, because he retains his copyright, can also use those pictures as he sees fit.

As far as the price that should be charged for these direct client sales, it completely depends on the specific specialization, the time that it will take to complete, and other expenses that will be accrued. Again, the first best step in determining what you should charge will be to check out what others in your special field are charging. Call or visit your local wedding photographer or portrait taker and simply ask about their fees. Check several professionals in your specialization since there is bound to be a range of fees charged, even if slight. Besides asking about the fees, ask how long they have been in business. This will allow you to gauge prices charged in conjunction with level of experience which will help you determine what price seems to be justifiable based on your own level of experience.

Don't forget to calculate your expenses into the price that you quote. There is a wide range of expenses you may need to take into account. Some of these expenses will need to be stated directly in the contract while others will be built into your overall price. Determining which expenses fall into which category depends on the nature of the task you are hired to perform. Certainly, you should think about the cost of your film

and the cost of developing the pictures. These are expenses that need not be itemized separately in your contract but are part of your overall price.

On the other hand, if you are hired to do a photo shoot that is a considerable distance from your home or office base, you may choose to charge mileage and tolls, if applicable. For projects that are time consuming, it is not out of bounds to charge an hourly rate for your time.

For photographers who are truly beginners, brand-spanking newbies, the value of doing work for free, or at radically lower prices than the competition, should not be overlooked. If you do not already have a stacked portfolio demonstrating your prowess in your particular area of specialization, consider offering free or steeply discounted packages to the first few clients who show interest in hiring you. The benefit to this tactic is threefold. You will build your portfolio, gain experience, and make contact with people who may serve as paying customers in the future.

A work for-hire project, on the other hand, is when a client pays a fixed fee or pays you an hourly rate and then takes ownership of the images, including ownership of the copyright. How this happens and becomes different from the general direct client sales is that the client requests it and it is written into the

contract. Clients who ask for this usually don't really need to have the copyright and ownership, but do so because of some misconceptions about the benefits of retaining the copyright or misconceptions about what calamity will befall them if they allow the photographer to keep those rights.

The downside for the professional photographer in a work for-hire situation is that the pictures could be ones helpful to his or her career, either as samples for a portfolio or, more likely, an income generator through stock photography sales. On the other hand, there are some work for-hire contracts that are so specific to one person or to one product that losing the copyright would cause little distress to the photographer since the images have such limited use or future value.

Chapter 17: The Power of Flash in Digital Photography

One of the aspects of photography that amateurs fear the most is the use of a flash. The misunderstanding of placing an alternate light source on a camera and thinking they are going to add too much light, or not enough, usually leads to people keeping their flash in the bag and hoping for the best with the natural light available to them. The thought that "natural" light is always best prevails and people go about taking their images never utilizing a great tool available to them. YES, beautiful, natural, soft light is always a great option. Yet, photographers should never avoid using an alternate light source when it can be of value. There are many times when the use of a flash can truly help your images. This is not only true when it is too dark, but a flash can really help your images even when there is enough natural light available! Here are just a few examples of where and when a flash helps. We will look at all of these examples in depth.

- When a long exposure has too much movement for a good image.

- To avoid "red eye" from the built-in flash.

- To brighten eyes and skin even in daylight.

- To allow the use of a lower ISO.

- To allow the use of a faster shutter speed.

- To add light to a dark subject.

- To help create even light when a subject would be dark if the exposure for the background is used.

- To create images where the shutter is dragged after the flash for incredible artistic images combining both the flash and natural light elements.

Let's start with how a flash works and different ways to control it. Simply put, you use a flash anytime you need to or want to add more light to a situation. This can be for a variety of reasons, such as those listed above. Start thinking of your flash as that friend you may have that you call once in a while when you have a favor to ask who is always there for you! A flash can be a great friend!

The best flashes are like most items in photography, the more expensive ones. Where I think you can get by with "off brand" lenses and other items in photography, a flash is one of the

items I always recommend purchasing as a name brand of the camera that you have.

Remember, the longer the shutter speed, the longer it stays open to allow light in and the wider the aperture opening, the more the amount of light. However, now you are adding an alternate light source by bringing in the flash. This will allow you to have more light when needed as well as to fill in light when necessary.

Your images, when the flash is in use, are directly affected by DISTANCE. The closer you are to a subject, the brighter it will be illuminated with a flash and therefore the light (both flash and ambient) needs to be controlled.

Cameras have what is known as a maximum sync speed for flash. This means, that when the shutter opens and the flash fires, the flash will be over by the time the shutter closes. If you set your shutter too fast (usually above 1/200 or 1/250 on most cameras), your flash will not sync since the shutter is closing before the flash is finished illuminating the subject. This means that the shutter actually opens and closes faster than the flash can record. Your result will be a black line on the side of your image.

To avoid this, you can only set your camera's shutter speed at its maximum sync speed or slower. Again, most cameras are

around 1/200 or 1/250 of a second. There is an exception to this situation. This is known as "high speed" sync and can be very useful if you need to photograph with a fast shutter to help record the action. Many flashes have this capability, but they have to be bought with this in mind. This is a situation where, in my opinion, having the manufacturer made flash really helps as the camera and flash know how to talk to each other properly. Having a high speed sync flash setting will allow you to move your shutter much faster than the original sync speed.

Chapter 18: The Business of Stock Photography_

Stock photos generally refer to pictures that already exist in the portfolio of a photographer. These pictures may or may not have been taken for a specific purpose or a specific client in mind. But, by the time they reach the level of stock photos, they are being sold to buyers who need them for catalogs, books or advertisements. Basically, stock photos are comprised of pictures depicting everyday things and everyday people.

There are instances when buyers of stock photographs are seeking specific images. For example, a magazine for horse lovers and horse breeders will need lots of different pictures of horses. The subject matter, or what the horses are doing and where they are doing it, are likely not to be very important. A photographer who happens to already have many pictures of horses could sell them as a group. But for the most part, the stock photography business is a way for photographers to make money from pictures that are not already earmarked for a specific purpose or a specific buyer.

The major consideration when deciding to sell stock photos is whether a photographer should sell directly to buyers or work

with a stock photo agency. Stock photo agencies do all the marketing and deal directly with client buyers. From the photos that are sold, they take a certain percentage and pay a smaller percentage to the photographer. This may seem counterintuitive to the novice photographer. Why give someone else part of your income to sell your pictures when you could sell them to buyers directly and keep all your money? It is possible to have your own stock photography business but changes in the industry brought on by digital cameras and the Internet make this proposition exceedingly difficult.

Before digital cameras and the Internet, the biggest problem facing both sellers and buyers of stock photographs was distribution. In order for photographers to make a profit in the stock photo business they had to deal in bulk. Not only did they need a vast supply of photos, they also needed to cultivate relationships with several buyers. Furthermore, there was the expense of delivering these photographs to potential buyers, waiting for them to accept and pay for the pictures or reject and return the pictures, in which case the process would begin again. This problem for the individual photographer was largely solved with the birth of the stock photo agencies. In return for the convenience of time, the photographer gave up part of the income they would have made from selling their pictures themselves. Though agencies typically keep more than fifty

percent of the picture's selling price, photographers find that, by dealing with these agencies, the expenses saved in time and postage, as well as the time freed up to take more pictures, actually put them ahead financially in the end.

The Internet and digital cameras practically solved the problem of distribution. Stock photography, more than any other area of the photography industry, has been transformed by computer technology. In fact, those wishing to work in stock photography nowadays have little choice but to do so digitally. But while technology solved one problem, it created another. The ease of making pictures and contacting numerous buyers simultaneously has flooded the stock photography market with pictures taken by everyone from seasoned professionals to computer savvy teenagers with their first cameras. This has created a situation where selling stock photos is more difficult than ever.

Where buyers first made out like bandits with the increasing number of photos available, they, too, are now suffering from the market saturation of pictures because they have to sift through so much more stock to find a product that is useful to them. In turn, this has created a situation in which novice photographers are finding it difficult to be noticed because overworked buyers are going back to established photographers who have a record of accomplishment and with whom they have

worked in the past. Those who are still determined to get into this business despite these obstacles are finding that specializing in one or two kinds of stock photography improves their prospects.

Chapter 19: Marketing Strategies for the Digital Photographer_

Whilst marketing strategies sounds a mouthful, it means putting more bucks in your pocket. Marketing is the commercial phase of transferring a product from one owner to another. In other words, you generate more sales. It has never been easier for the photographer to take effective steps to generate these extra sales. There are more photographers than ever before, but the market has also boomed exponentially so it makes economic sense to cash in on that boom.

Whilst there are many effective steps you can undertake, they do have international, national, and also local effects; some will have an immediate effect, and others will have a long range benefit.

Immediate Local Impact._

You do not have to have a PhD in photography to work out that the area, fifty miles from your front door, is the geographical

area you know best. To widen your net in your immediate area will have immediate impact.

Your Marketing Plan

Identify the area you wish to exploit. To keep you on track all the time, write it down. It may appear time consuming, as indeed it is, but it is a document that you can refer to often, and see if you are achieving your individual targets. No one else need ever see this document, but it is important that you are able to identify your strengths and weaknesses.

Market research

How does your customer rate you? When you deliver your finished product, send out a preprinted questionnaire. If people are not hiring you for the second time, because of a mistake you made the first time, then you need to know about it, to be able to take corrective measures.

Like any other business, the photographic business has an element of repeat orders. If you have photographed someone's wedding well, they may not want you on the honeymoon, but your name may well be remembered when "official" photographs are needed for the birth of a first child, or a

christening. If you are not getting your share of repeat business, why are you not getting it?

You cannot rectify the problem without isolating it. In this aspect it will throw up your competitors' strengths, and you need to know how strong they are. Is there a weakness there you can exploit, either by undercutting their prices, or by going the extra mile on service? You need to know where exactly you stand in your local workforce and in relation to your competitors.

Unique marketing points _

What makes your individual business unique? These are the points you need to communicate when carrying out target marketing. When you have taken commissioned photographs, are you willing to send a free photograph enlarged, preferably one that "tugs at the heart strings" because its content is emotional? Are you prepared to go that extra mile where service is concerned? If you exceed your customer's expectations every time you work, then you will get repeat business. Repeat business is your cornerstone to success. Sloppy work, and inattention to detail always yields sloppy returns.

When offering your services to individuals for any form of "people photo," are you prepared to scan and restore a possibly damaged favorite old photo that may offer you the commission?

Are you prepared to give the customer a free compact disc with the images on?

Exploit potential

There are millions of people with both pets and cameras. However, it is harder to take a professional photo with yourself and the mutt in it! Are you exploiting the add-on services to their full potential? Sometimes people love their animals more than other people. Animals always exert an emotional pull. Get yourself a picture of a dog, the cuter the better, and have it made into a tee shirt, or get the image transferred to a coffee mug. Go to the local park near where you live, and wear this tee shirt. You don't need your dog! - Just the camera, and offer to have one made when someone admires the tee shirt (after taking the photo).

Competition

Find out exactly what your competitors are doing, and what exact services they are offering. Email them, or telephone and ask as a prospective customer. If you have the email, then you have a permanent copy for future reference. You also need to check these prices periodically and keep your information current. You need to know how many competitors there are, and

whether or not your pricing structure is competitive. Other variables should be considered, the customer after sales service, and their promotional services.

Identify your target audience

By careful analysis of your competitors' strengths and weaknesses, you may be able to find a gap in the market that you can easily tap into. If you are not able to analyze this information for yourself, speak to a professional who can!

If you specialize in wedding photography, then your primary target is the newly engaged couples who are reading the engagement ads in your local paper. Can you persuade a local jeweler to place an advertisement for your services in his or her shop?

Articulate your short, medium and long-term objectives

Is it necessary to target more customers? Can you handle the excess demands on your time, without letting your existing client base suffer? Or are you looking for a wider client base for existing photographs? Where can your business realistically expand? Sometimes it is necessary to be exceptionally ruthless here because without this, a marketing strategy is doomed to

fail. You have to be able to measure that the steps you are taking are creating the results that have been specified.

How to choose a stock library_

There are general stock libraries on the Internet that will market all types of photography. The question is how you can find the best agency for you. Sell Your Photographs has a library and thousands of listings for you to inspect and contribute to should you choose to. If you decide to sell stock photographs, it will probably widen your scope as a photographer. Remember that the clients who buy stock photography are not just in the printing and media business but they are also printing calendars, and the greetings card market. If you are considering playing the "stock market," remember a few basic rules, it is not all about creativity. Treat every agency as a very valued client, communicate with them regularly so that you can listen to market trends as the market has become more discerning as it evolves.

Freeing Your Time to Take More Photographs_

Hiring a Sales Representative

For some, the idea of any form of marketing is an anathema; some people are just too creative to combine being an artist with

the more prosaic demand of running a business. For these people, or for the just plain lazy, there is actually another alternative. You can engage an established sales representative on a commission only basis. Remember that this involves no cost to yourself, other than producing a creditable portfolio, but your earning power is diminished because when a sale is negotiated you will lose part of your profit in commission. The commission is around thirty percent of the net sale.

This is an advantageous idea, if you are a specialist, as the sales representative that you have selected will have the contacts in your field. They will have a better idea of the true value of the image, and if it is good enough, they will be able to successfully negotiate the price. Also, a buyer may be more predisposed to see a sales representative as they will be carrying the work of more than one client. This may also work for you if you are not within commuting distance of a big city.

Selecting a Sales Representative

The photographer's market book has a complete list. If you are situated within a cosmopolitan area, but still decide this is the way you want to go, then also try phoning the large advertising agencies and asking for the names of their most consulted representatives.

Chapter 20: Tools and Techniques That can Enhance Your Photographic Experience

ExpoDisk – White Balance and Exposure Settings

The ExpoDisk is a filter that you place over your lens to evaluate the **Incident Light**. It serves the same function as a **Light Meter** but also gives you a way to set the **White Balance**.

Next, place the ExpoDisk over your lens and stand as close to your subject as you can, pointing the camera toward the spot where you will be standing when you take the photo. By doing this, the ExpoDisk will be exposed to the same lighting conditions as the subject to be photographed. Snap a picture without changing any settings. This will produce an image that can be used to set a **Custom White Balance** in your camera or for post-processing. The exact procedure will depend on the camera being used.

If your exposure is correct, you will see a single vertical line in the center of the histogram for the White Balance image. ExpoDisk.com has some great training videos to help you through the learning curve.

ColorChecker Passport by X-rite

When you edit photos, you simply select your camera from a menu and the software will apply your custom profile.

Spyder4 — Monitor Color Calibration

This is one of several devices that are used to calibrate monitors. The software walks you through the process step-by-step. The Spyder is draped over the top of the monitor and held in position by a counter-balance on the cord. When you start the program, a page will display the location for the Spyder during calibration. When you start the calibration cycle, a series of color swatches will appear on the screen under the Spyder. For each swatch, the Spyder will record what it sees and compare it to the correct color of the swatch. When the process is complete, the software will create and store a file on your computer that will automatically correct any future color errors on your screen.

Tethered Capture

Photo editing software programs like Lightroom will allow you to connect a Laptop, Tablet, or even a desktop computer to your camera so that you can see results immediately on a larger

screen than your camera's LCD screen. If you have Lightroom, you can edit your image and decide if you need additional shots.

TetherTools.com is one resource for devices that make it easy to use tethered laptops and tablets. They also make a wide variety of related products. The image below shows how an iPad might be used.

Moveable Eyepiece

To use this device, you remove the eyecup from your camera and snap this device on in its place. It comes with a number of adaptors so that it will fit most popular brands and models.

The barrel of the device — where it says SEAGULL — is the diopter adjustment and it is more than adequate for my needs. It does not lock in place so you have to adjust it from time to time.

Because the barrel and eyepiece rotate around the mount, you can view your scene from the top, sides, or bottom of the camera. It is particularly valuable when the camera is very close to the ground.

HoodLoupe

If you have ever tried to look at your LCD screen in bright daylight, you know how difficult that can be. Depending on the

direction of the sun, it can be anywhere from annoying to impossible. The device is a Hoodman and it is held on the camera by industrial rubber bands. The device is $80 and the bands are another $20. That is the price on Amazon.com. If you want to magnify your view, that attachment will cost an additional $40.

Chapter 21: Uses of Histograms in Digital Photography

A histogram can show you whether your field of view is weighted towards the dark or light end of the spectrum which can throw off your light metering.

Have you ever taken a photograph and when you got it home and downloaded it to your computer, you noticed it didn't look ANYTHING like the back of your LCD on your camera? This is a common occurrence and there are a variety of reasons that explain how this can happen.

This is a VERY important part of your camera system and one you need to pay VERY close attention to while photographing.

Use your camera manual and look under histogram if you cannot seem to locate a screen that looks like this. Usually it can be found by pressing the info button on Canon or pressing up on the Nikons back button system. The histogram is the graph that looks like "mountains." You may see two histograms, including one that has red, green and blue lines. For exposure purposes, use the grey scale one.

The MOST important part of the histogram is to make sure that you are not clipping all the way to the far right if you have whites. This would mean that there are no details and the image has over-exposure in this area.

You MUST understand that images can look good on your LCD and yet NOT have the correct exposure. In ALL of the examples below, anyone of these could have looked good on an LCD, based on many factors such as the LCD brightness settings and the environment in which the LCD is being viewed!

If you are in a situation where the lighting is not even and you have to choose whether to overexpose or underexpose, the rule is that it is BETTER to slightly underexpose. It is impossible to pull details out of images where there are no pixels recorded. However, in an underexposed image, at least pixels are recorded and you can use editing software to pull the details out.

The rule is to err on the UNDEREXPOSED side in digital photography.

Take Action: Locate the histogram display within your camera. You will most likely need to use your camera manual to do so.

A histogram is a visual representation of every single pixel used in the image. The advantage is that you can see right away how your photo is exposed and make any necessary adjustments on

the fly. The reality is that the screen on your camera is pretty small, and you might not be able to judge the exposure of your image just by looking at the picture itself.

You will find that photos can look very different on the back of your camera - especially on a bright day - than they do on your computer screen. Histograms help you avoid any surprises or disappointments.

To access the histogram for an image, press the DISP button once or twice while reviewing the image (depending on your camera brand). Most camera models have a few different options that you can toggle between by pressing the DISP button again.

Get in the habit of reviewing your histograms when you are shooting to get a better idea of your exposures. Nothing kills the excitement of a great photo session quite like getting home to find that your pictures are actually poorly exposed.

Chapter 22: Advancing Your Digital Photography

Continuing to get better at photography really comes down to three things. Those things are practice, feedback, and more learning. That is kind of obvious, in a sense, but how and where you might go about doing these things isn't so obvious.

How to Get in Some Practice

The first thing you need to do is practice. You need to practice so that some of these things come naturally. The good news is that this should be fun. Practice in this context just means going out and taking pictures of things that interest you. It can be a trip, just wandering around, or taking pictures of your family. As you do so, you will get more comfortable with the exposure controls. You will learn how to line up and compose pictures. It isn't like practicing a sport with all the pain and mindless repetition – it is an enjoyable process.

You can also practice by just walking around your house. Move from lighter to darker areas and take pictures in each so that you

will have to adjust the exposure to take the pictures. You should have some familiarity with the menu and other key settings as well. Use the exercises in this book to help with that process.

If you want, you can also give yourself assignments. This applies when you have your camera but you are not in a place or around people that you want to shoot. Some of the more common ones that people do are challenging themselves to:

- Photograph light

- Photograph shadows

- Photograph particular colors

Frankly, the best way to practice is just to build your portfolio. That is one of the reasons I encourage you to set up a web presence of some sort. It gives you a sense that your photography is actually building. You'll see your work expand outward and upward. You will want to take additional photographs to add to your portfolio. Then, as you start building out certain categories, you'll see gaps you need to fill. The portfolio causes you to practice, but in a way that seems fun and useful.

Ways to Get Feedback on Your Work

You definitely want others to review your photography and give you an honest appraisal. Where and how to do that though?

Having your family and friends review your work is a good start, but not the best way to go. First of all, they will say nothing but nice things in an effort to spare your feelings. Further, while everyone's opinion is valid and it matters, your friends and family may not know one thing about what separates a good photo from a bad one. They may like only pictures of kittens in funny hats. Plus, you don't want to constantly beat them down trying to get them to look at your pictures.

It would be great if you could have an expert photographer review your work periodically. But that's not realistic. If you are interested in doing that, however, many photographers offer reviews of your work online. You simply set up a call, send them some of your pictures, and then go through them to get their feedback. That can be helpful, but it is not the sort of thing you will want to do every month. It isn't free either.

The best thing to do is compare your photos to others on a consistent basis. You can do it yourself, of course. One way to do it is to upload your photos to 500px. As mentioned previously, when you do that, you will end up with a score for your photos,

but frankly I wouldn't put too much stock in the score. Rather, just compare your photos to the ones around it in the Fresh, Upcoming, and Popular pools. Seeing your photo there surrounded by peers really helps to put it in context.

There is yet a better way to get some feedback on your work. Check out a free website called **Pixoto**. With Pixoto, your pictures go head-to-head against other photos in Image Duels.

How to Keep Learning about Photography

Finally, it is important to keep learning about photography. There is an infinite number of things to learn already, and photography keeps changing so that there is more to learn all the time.

How do you go about doing that? There are a lot of ways. For online photography tutorials, check out **Lynda.com** and **Kelbyone.com**, both of which are excellent. But they do cost money, and there are others that are free. It is fairly common for photographers to share a little of what they know on their website.

Conclusion

Digital photography makes use of a number of factors in addition to those affecting exposure. The framing and composition of the picture, focus, and graphic image processing on the back end are just as important.

And that's what makes photography fun and an art form. Nature provides only the raw materials. Your mind uses your camera and other tools to create the picture from those raw materials, just as a painter uses pigments and canvas, or a sculptor uses marble or wood or clay.

The artist who wishes to make photography a serious profession must remember that specialization, passion and dedication are key to making it successfully. A photographer willing to specialize in a field which is not already saturated by others photographers is more likely to get clients and build a consistent and growing clientele base.

Photography is a field in which you will spend as much time trying to find clients or trying to get them to pay you afterward as you will actually be snapping away pictures, at least in the

beginning. The importance of proper advertising cannot be overlooked. Nor can the importance of having clients sign contracts which clearly state the payment that is expected of them and when that payment is expected. Proper paperwork keeping is essential and along these lines so is proper maintenance of tax records.

Photography is a field in which many unprepared people are entering because it seems simple on the face. Snap a picture, develop a picture (or print one out), hand it over and collect money. It takes much more work than that and the photographer who enters the profession willing to put into practice the hints listed here will be well ahead of the pack.

Printed in Great Britain
by Amazon